drawing
in 10 steps

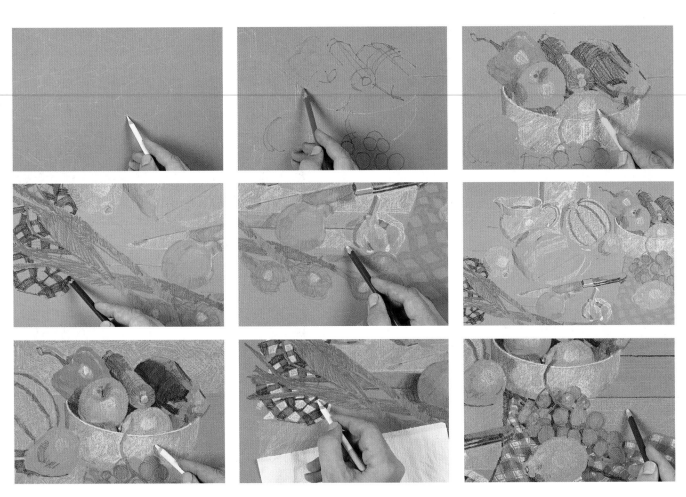

drawing
in 10 steps

Ian Sidaway

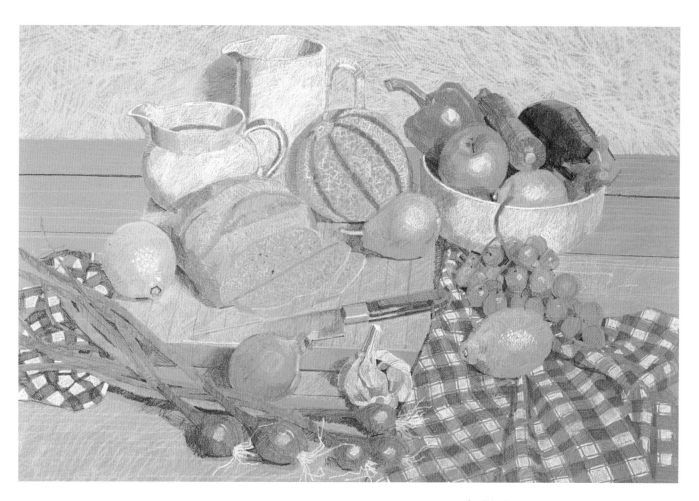

hamlyn

First published in Great Britain in 2006 by
Hamlyn, a division of Octopus Publishing Group Ltd
2–4 Heron Quays, London E14 4JP

Distributed in the United States and Canada by
Sterling Publishing Co., Inc.
387 Park Avenue South, New York, NY 10016–8810

ISBN-13: 978-0-600-61482-1
ISBN-10: 0-600-61482-4

A CIP catalogue record for this book is available from the British Library

Printed and bound in China

10 9 8 7 6 5 4 3 2 1

contents

introduction 6

before you begin 8

Step 1 proportion and shape 18

Step 2 perspective 26

Step 3 line 34

Step 4 tone 42

Step 5 colour 52

Step 6 texture 62

Step 7 pattern 70

Step 8 advanced techniques 78

Step 9 composition 88

Step 10 bringing it all together 94

taking it a step further 110

index 142

acknowledgements 144

introduction

Drawing is intuitive. It is among the first skills we reveal as very young children, and yet the ability to draw often becomes lost and forgotten because greater emphasis is placed on mastering academic and business skills as we grow older.

It is possible to rediscover drawing, however, and in many cases all that is needed is a little practice. You probably draw already without knowing it: tracing designs in sand with a stick, on the frosted panes of a window with your finger and doodling subconsciously on the back of an envelope are all forms of drawing. You just need to bring out this latent skill, and to channel it so that it becomes more focused. With practice, you will find drawing worthwhile, useful and profoundly satisfying.

Newcomers will find it helpful to start by playing and experimenting with various drawing materials. In order to make a copy or interpretation of what you see it helps to have at least a basic knowledge of the materials available and the uses to which you can put them. You should also get to grips with certain basics of drawing – scale, shape, perspective, tone, colour and texture. Consider subject matter carefully, too. Part of an artist's craft is deciding on the merits of a certain subject and in editing the visual information he or she sees into something that will make a good image. Choose your subject well – if it is something that you have an interest in, this will help to focus your attention.

This book will get you started in the right direction. A mini art class, if you like, the book is structured in such a way that

you focus on just one aspect of a drawing with each project. From making the first marks to arranging a successful composition, you will see clearly how each stage of completing a drawing is achieved, including getting the right perspective, adding tone, colour and texture, and using advanced techniques. A different drawing material is used for each step, giving you the opportunity to experiment with a wide range of media: chalks, pencils, charcoals and pen and ink. Having practised a step a few times, you can change your materials to build on your experience further.

With each drawing you complete you will develop your drawing skills, becoming a little better both technically and at 'seeing' and interpreting the subject before you. Put in the hours and the learning curve will be clear; satisfaction and a real enjoyment of the craft are sure to follow close behind.

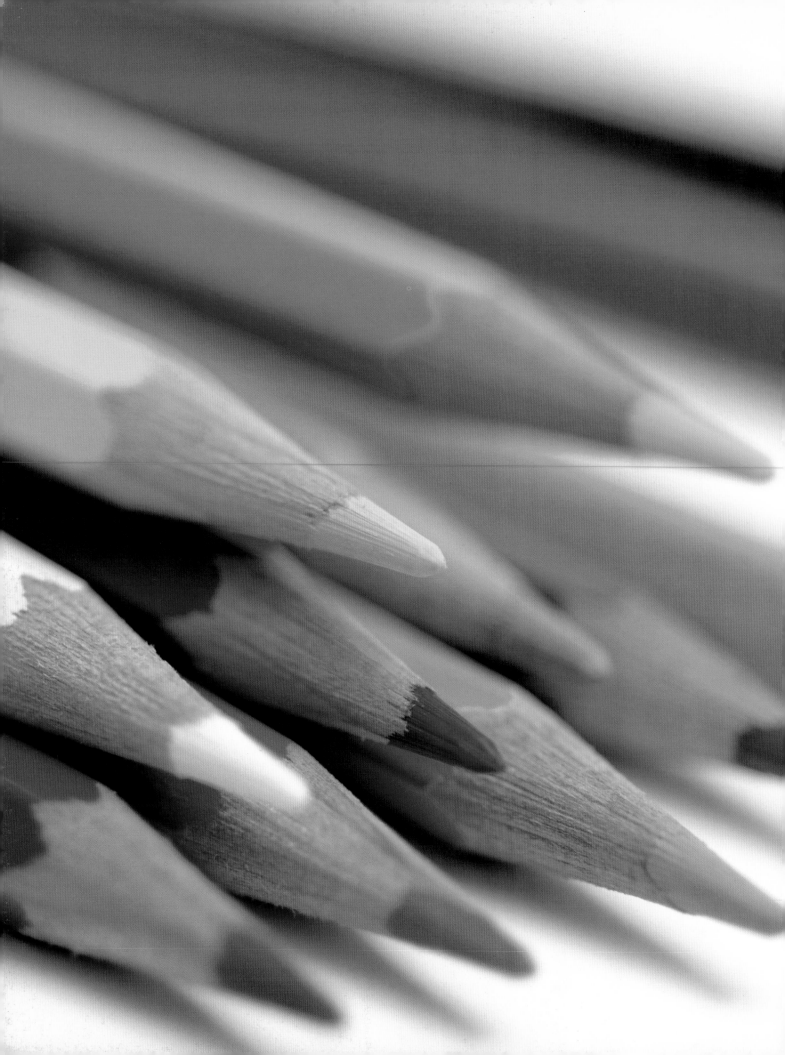

before you begin

choosing the right materials

Artists have exploited a wide variety of materials and equipment over the years and manufacturers have responded by producing an incredible range of art materials, most of which are easily and readily available. When buying drawing materials, you will find that they have advantages over those for painting in that they are relatively inexpensive, last a reasonably long time and are very easy to carry. The materials you will need to follow the projects in this book, and to produce compositions of your own, are available at most art stores. Beware when buying, however: art stores are seductive places and you may be tempted to purchase more than you actually need.

Shopping list

Hot-pressed watercolour paper, 300 gsm/140 lb	No 2 sable brush	**Drawing leads:**	Light ochre
White cartridge paper, 120 gsm/60 lb	White gouache	Sepia	Olive
White cartridge paper, 300 gsm/140 lb	Putty eraser	Terracotta	Mid green
Mid-grey pastel paper, 160 gsm/90 lb	Blending stump	Black	Light green
Beige pastel paper, 160 gsm/90 lb	Fixative	**Pastel pencils:**	Lime green
Scrap paper	Pencil sharpener	White	Light violet
2B graphite pencil	Ruler	Light grey	Violet
2B thick graphite stick	Stick charcoal	Mid grey	Indigo
3B graphite stick	White chalk stick	Dark grey	Ultramarine
Reed pen	**Charcoal pencils:**	Cadmium red	Light blue
Dip pen	Medium-soft	Crimson	Burnt sienna
Fine steel nib	Hard	Cadmium orange	Burnt umber
Medium steel nib	**Artist's pencils:**	Cadmium yellow	Terracotta
Black Indian ink	Terracotta	Lemon yellow	Black
Bisque waterproof drawing ink	Black	Naples yellow	
	Lead holder	Yellow ochre	

DRAWING SURFACES

The surface upon which a drawing is made is commonly known as the support. When it comes to drawing this is, invariably, a type of paper, although you can draw on many surfaces, including card or wooden boards prepared with gesso (a white, plaster-like base). The type of paper that you choose is very important and will have an impact on the marks and effects that you can make and how your chosen drawing material behaves.

There are, essentially, three types of paper surface: hot pressed, which has a smooth surface; cold pressed, sometimes known as 'not' (not hot pressed), which has a slight texture; and rough. Drawing materials that are relatively hard – graphite, coloured pencils and some artist's pencils – perform very well on smooth, hot-pressed papers, allowing the artist to make precise and textural marks with a full range of tonal density. The same is true when using ink: smooth papers allow the nib to move freely over the paper surface without snagging, which can result in blots and splashes.

When using softer 'friable', or crumbly, drawing materials, such as charcoal and soft chalks the story is slightly different. On hot-pressed papers, the dusty pigment from these materials sits loosely on the paper, unable to attach to the smooth surface. This makes it difficult to make dense, dark marks or to build the work up in layers. Such media are much more effective on medium-grain, cold-pressed papers, which have a degree of texture, or surface 'tooth', for the pigment to adhere to. You can also use rough papers, which will result in bold drawings that are heavily influenced by the texture of the paper.

Several manufacturers produce coloured and tinted papers specifically for use with soft drawing materials like charcoal, pastel pencils and chalks. These fall into two groups: woven paper and laid paper. A sheet of woven paper is made by picking up the pulp on a fine wire mesh, which results in the fibres being knitted or woven together in a random way. This is the way most papers are made. A sheet of laid paper is made by picking up the pulp on a wire mesh that has the wires running in a grid pattern, parallel to one another. You can identify laid paper by holding it up to the light: a series of fine lines left by the mesh is visible.

All papers are sold by weight, which describes the thickness of the paper, using either grams per square metre (gsm) or pounds per square inch (lb): the higher the figure the thicker the paper. Cartridge paper (a smooth hot-pressed paper), also known as drawing or Bristol paper, is mostly used for drawing.

There are countless other papers available, many with special surfaces. There are also some exciting innovations from countries like Japan, India and Thailand. They all make excellent drawing surfaces and should provide you with limitless opportunities for experimentation.

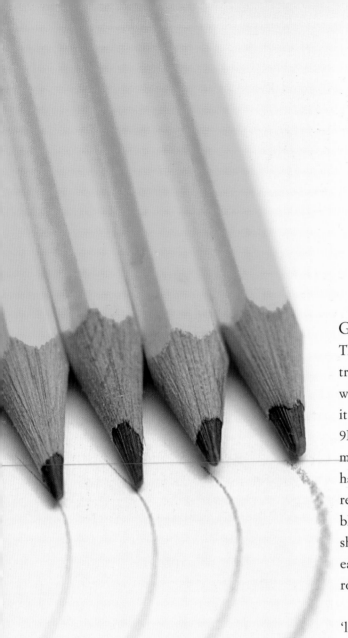

GRAPHITE

The graphite pencil is familiar to everyone, although few realize its true potential. Traditional graphite pencils – lead strips encased in wood – are available in a range of grades. In most cases, although it depends on the manufacturer, the hardest pencil in the range is 9H and 9B is the softest. A good all-round pencil, HB, is in the middle of this range. For drawing you will seldom need anything harder than H. For example, a 2B pencil, if used correctly, will render a full range of tones from very light grey to a deep, dense black. Wooden pencils have either round, hexagonal or triangular-shaped barrels. The choice is personal. Hexagonal barrels are easier to hold for long periods and provide a firm grip, while a round barrel is easy to roll between the fingers as you work.

Graphite is also available as solid pencil-like sticks, or 'leads', which, owing to the shape of the point, can make a wider range of marks. You can buy various thicknesses and grades of graphite, as well as coloured leads, to fit holders that have a clutch mechanism to reveal more of the lead as it wears. You will also find square, rectangular and round graphite blocks. Graphite powder is a dust that is rubbed into the paper and 'worked into' using more graphite or erasers.

CHARCOAL

Charcoal is perhaps the simplest of all art materials, consisting of carefully carbonized, or burnt, wood. Today most stick charcoal is made from willow – although beech and vine charcoal also exist – and is available in varying lengths, thicknesses and grades of hardness, as well as in rectangular blocks and irregular chunks. Compressed charcoal is made by binding charcoal dust together to form a solid. It is harder than traditional charcoal and is made into blocks, short sticks and strips that are encased in wood or held in holders. Like stick charcoal, compressed charcoal is available in varying degrees of hardness. Both types are messy to use, but you can keep your fingers clean by wrapping the charcoal in aluminium foil.

CHALKS

Also known as carré sticks, chalks are made using a pigment and a binder and are harder than pastels. They are square in profile, can be sharpened to a point and held in a holder. Traditional colours are black, white, sepia, bistre, terracotta and sanguine. You may also find a range of greys, browns and ochres. The colours produce wonderfully subtle drawings, particularly when several different shades or colours are combined together on a tinted paper.

ARTIST'S PENCILS

The traditional colours used for making chalks are also available as artist's pencils. Some of these also contain wax, which means they can be used without fixing, however this also makes them difficult to use with erasing techniques (see page 65). You can sharpen these pencils in the same way that you would sharpen a graphite pencil. You may also find different coloured 'leads' to insert into a holder with a clutch mechanism for lengthening or shortening the point.

PASTEL PENCILS

Coloured pigment, held together with a binder, is used to produce pastel pencils in a reasonably comprehensive range of colours. They can be sharpened to a point and you can smudge and blend them together on the paper using your finger or a blending stump (see page 16). You can also erase them with care. They respond particularly well when used on coloured or tinted backgrounds. You can buy pastel pencils in sets or separately, which means that you can buy just the colours you need.

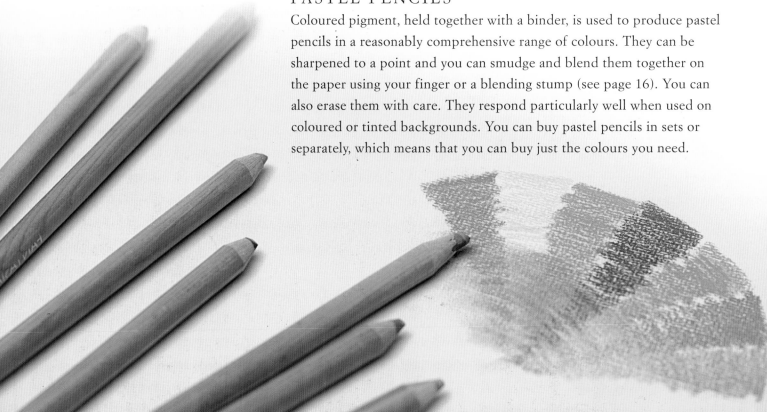

DIP PEN AND INK

Inks are available in a range of colours, the most traditional ones being sepia, bistre and black. They are either water-soluble when dry, or waterproof. Water-soluble inks are easier to correct, but are not as easy to find as waterproof versions. Both can be diluted with clean water to produce a range of tints and shades.

There are numerous pens and brushes for applying ink. Nib holders will take steel nibs of varying size and shape: some are even double-ended so that two nibs can be held at the same time. Each nib gives a different quality and thickness of line and some work better on rougher papers. Bamboo and reed pens are also used. The former are inflexible and give a dry, course mark with a distinct quality, while the latter are flexible and deliver a line that can alter in width and character. Bamboo pens are very hard wearing, reed pens less so: they wear and the nib often needs to be re-cut using a sharp craft knife. You may also find traditional quills made from goose feathers. These are particularly enjoyable to use and leave a wonderfully expressive line.

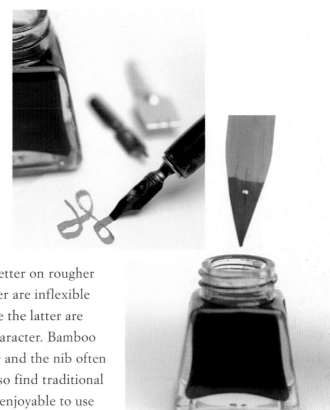

COLOURED PENCILS

Coloured pencils are similar to pastel pencils but contain wax, which makes them more difficult to erase. They also come in a far greater range of colours. The effects of coloured pencils are more subtle than those of other media, and this makes them more suitable to use on white backgrounds. Like pastel pencils, these are available in sets, or individually, allowing you to build up your colours over time.

ERASERS

Erasers are not used simply for making corrections, but are important mark-making tools in their own right. They enable you to create many different effects, some of which would be difficult, if not impossible, to achieve using the drawing medium itself. They are inexpensive and you should equip yourself with several different types. Avoid erasers that are brightly coloured, as they may leave traces of colour on your drawing.

Erasers are made from various materials and have a range of different uses. Putty erasers are soft and can be moulded or cut to shape. They are very good for tidying up dirty areas of clean paper and for lightening tones. However they get dirty very quickly, especially when used with charcoal and chalk. Putty erasers make relatively soft-edged marks. Plastic and India rubber erasers are harder and produce crisper marks. They do not pick up as much pigment as putty erasers, so do not get quite so dirty. They can be cut to size and shape as required.

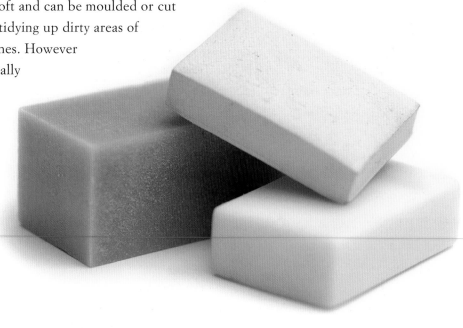

BLENDING STUMPS

Many types of drawing material are such that, until fixed, you can move, smudge and manipulate the pigment once you have applied it. Although you can do this with your fingers, rolled or pulped paper 'blenders' will make the process cleaner and more precise. Sometimes known as stumps, torchons or tortillons these blenders are available in various sizes. Once dirty they can be cleaned, either by unrolling a clean section of paper or by rubbing them on fine-grit glass paper. Cotton wool buds can also be used for the same purpose.

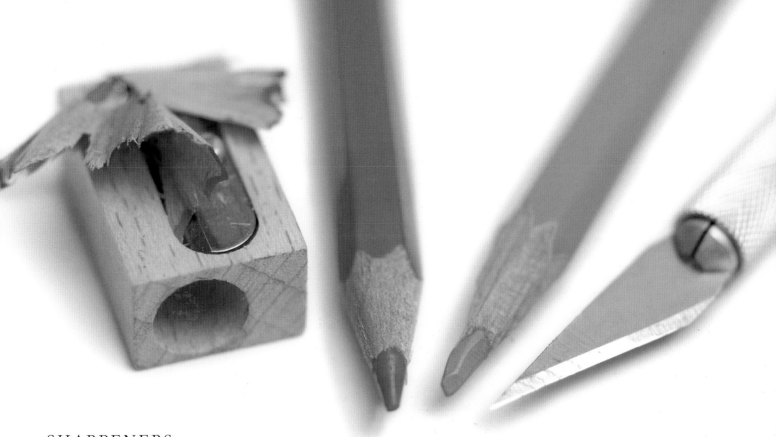

SHARPENERS

It is very important to keep your drawing implements sharp. A blunt drawing tool creates a dull, uniform line and is perhaps only of use when blocking in large areas of single tone or colour. Pencil sharpeners are inexpensive and can take drawing implements of varying diameter. However, they do get blunt relatively quickly, and will cause soft drawing tools like charcoal or pastel pencils to break during sharpening. Although all sharpeners are excellent for sharpening pencil-shaped graphite sticks, desk-mounted sharpeners can be a little too vigorous for soft 'leads'.

By far the best way to sharpen drawing tools that have the 'lead' or pigment strip enclosed in wood or carré sticks and drawing chalks, is to use a sharp craft knife or scalpel – suitable even for very soft materials. You can also tailor or shape the point to suit. Sandpaper blocks are also very useful, especially for maintaining some kind of point on graphite sticks or blocks and chalks.

FIXATIVE

Fixative is important, not only to preserve and protect your finished image, but to secure the loose pigment to the background during the drawing process, enabling you to work over in layers. Available in CFC-free aerosol cans and in bottles with a pump-action spray mechanism, you should always use all fixatives according to the manufacturers' instructions and in well-ventilated spaces.

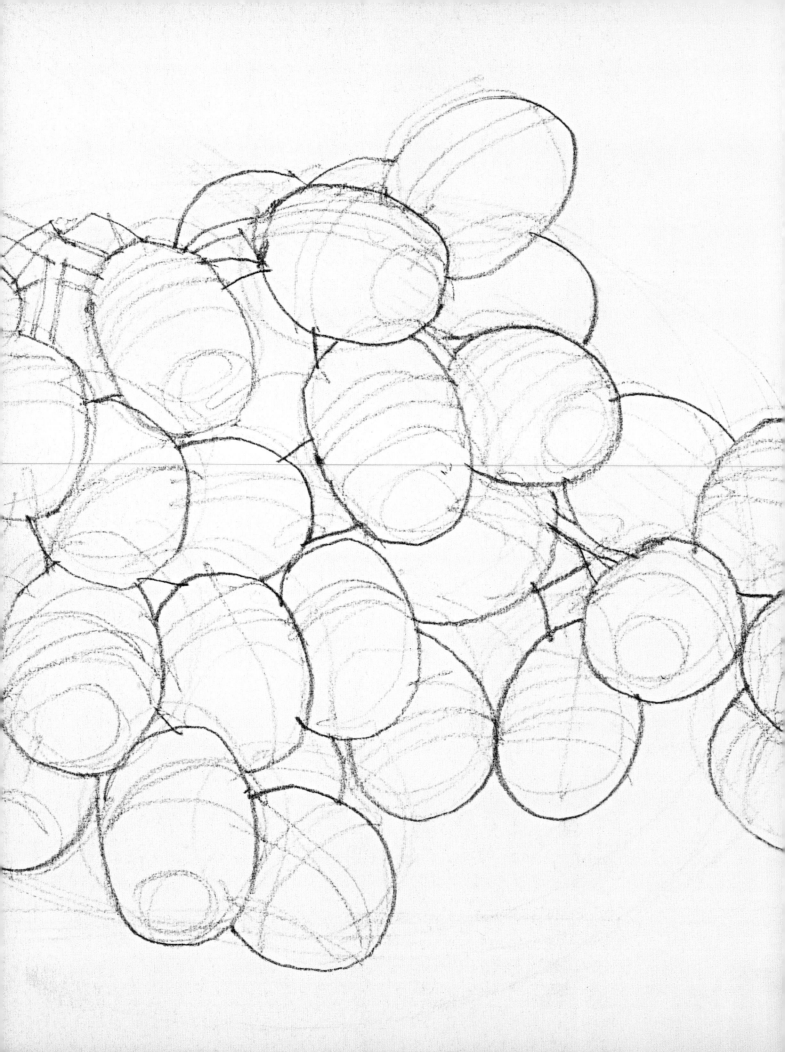

Step 1

proportion
and shape

focus: grapes

Materials

White cartridge paper, 300 gsm/140 lb

Medium-soft charcoal pencil

Putty eraser

Before spending any time on detail, colour, tone or texture, it is essential that you establish the correct shape and proportion of your subject in relation to its surroundings. This will provide you with a proper foundation on which to build. If this stage of the drawing process is overlooked, the completed work is unlikely to look quite as it should. Furthermore, trying to remedy any faults later on will almost certainly cause unnecessary complications and make the whole drawing process far more difficult to master.

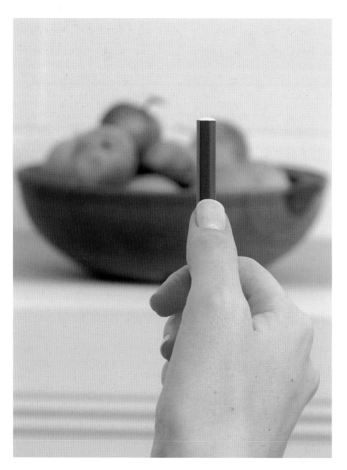

MEASURING

In order to draw something correctly, artists usually estimate its size and shape in relation to other objects in the composition. For example, in this exercise, how long is the stalk in relation to the length of any one grape? Experienced artists often accomplish this simply by eye, but even they might make a few initial measurements to get started.

You can do this by holding out your drawing implement, say a pencil, at arm's length. Look down your arm to the pencil and beyond to your subject. Position the top of the pencil at a point on the subject that marks one end of the required measurement and move your thumb along the shaft of the pencil until it comes to rest at the point on the subject where that measurement ends. You can then transfer this unit of measurement to your paper. A single unit can be used over and over to compare distances or several different measurements taken – as long as your measuring remains consistent the drawing should be correct.

NEGATIVE SHAPES

Negative shapes are those that surround an object as opposed to the 'positive' shape of the thing itself, and are usually instantly recognizable: think of the spaces between the legs of a chair or the space through the handle of a cup. Negative shapes are often simpler or clearer to define than the positive shape of an object and are a useful means of checking how correct your drawing is.

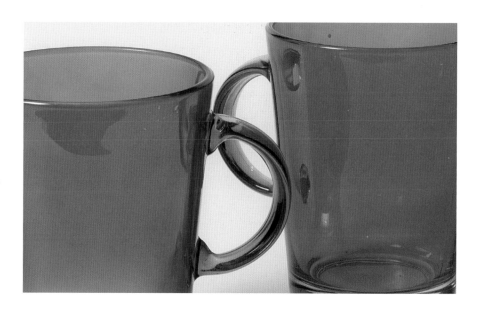

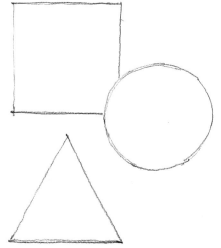

SHAPE RATHER THAN SUBJECT

When analyzing a subject for drawing, try to think of it in terms of abstract shapes and not as an object as a whole. Artists often check for accuracy by looking at a drawing upside down or in a mirror, where faults are often easier to see. All drawings can be rendered using three basic geometric shapes: the square, the circle and the triangle. Turned into three-dimensional forms – a cube, a sphere and a cone – these can be elongated and stretched to become rectangular or ovoid, tall, thin, fat or squat, without altering their basic shape. If you begin a drawing by breaking the subject down into these basic shapes, you will provide yourself with a good foundation on which to build.

Simple shapes: The three basic shapes are the square, the circle and the triangle.

Simple forms: The basic shapes are translated into a cube, a sphere and a cone.

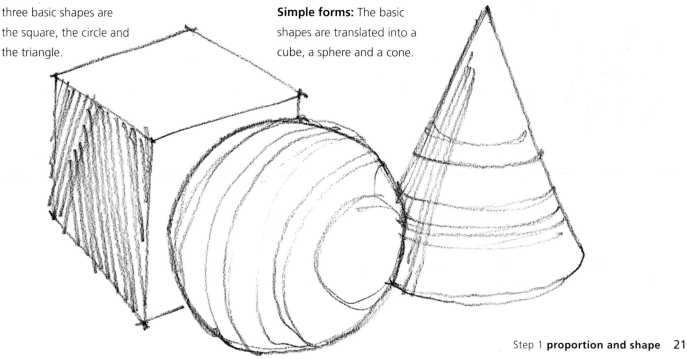

DRAWING THE BUNCH OF GRAPES

A bunch of grapes has been chosen for this exercise. It has a distinct shape as a whole but is made up of many similar small shapes. The idea is to draw the individual parts correctly in order to create the whole.

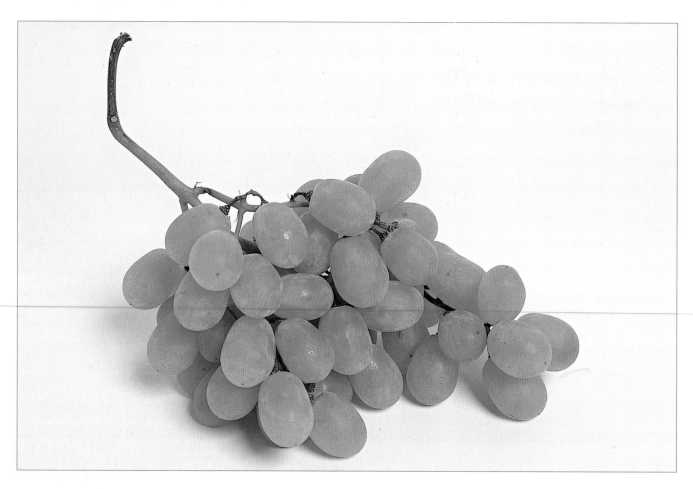

1 Begin by establishing the correct proportion of the bunch of grapes: you can do this easily by taking two measurements. The first is a vertical measurement from the tip of the stalk to a position that is level with the base of the lowest grape. Use the charcoal pencil to transfer these two points to your paper. The second measurement is the distance from the extreme left edge of the grapes to the extreme right. Again, mark the two points on your paper.

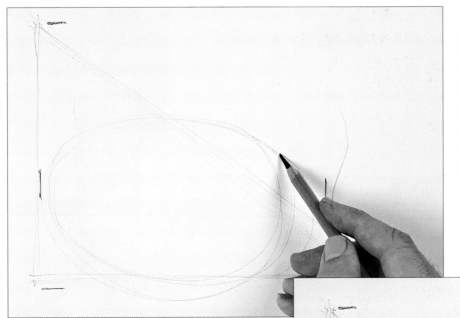

2 Consider the basic shapes that make up your subject. From the tip of the stalk to the last grape on the bunch occupies an approximately triangular shape, so lightly draw three straight lines on the paper. The bunch of grapes itself is roughly oval and sits within the triangle outline. Again, draw this lightly on the paper.

3 Once you have established the overall shape and proportion of the bunch, you can draw the approximate shape of the stalk. Draw, roughly, the position and number of grapes, using a light charcoal line.

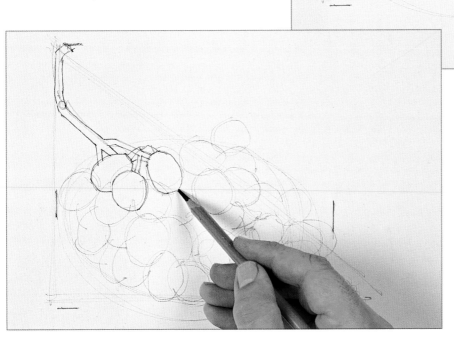

4 Once happy with this, you can redraw the bunch more carefully using a darker, more deliberate line. Draw the stalk first, paying attention to its curve. Now redraw each grape in turn, positioning it in relation to the grape next to it. Look at the 'negative' shapes around and between the grapes as well as the 'positive' shapes of the grapes themselves.

5 Continue to build up the drawing. As you do so, take time to appreciate how the orientation of each oval shape changes slightly from grape to grape.

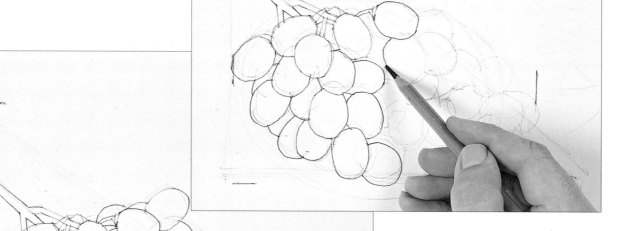

6 Pay particular attention to each grape's position on the bunch: grapes that are in front need to look in front, while those positioned at the back should also appear so. This may seem obvious, but a misplaced line can easily result in a grape that appears to be neither in front nor behind.

7 With the initial drawing complete and the bunch of grapes positioned to your satisfaction, you can remove any construction lines or marks that jar by working over the drawing, carefully, using the putty eraser.

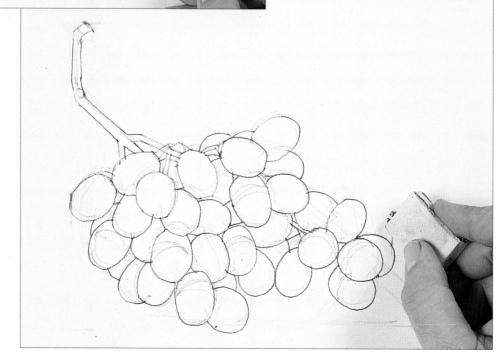

8 Your drawing will resemble a bunch of grapes, but may be lacking in depth because the aim of this exercise is to establish shape rather than form or volume. You can, however, remedy this by adding a series of contour lines that follow the curvature of each individual grape. You can complete the drawing by 'tidying' up any unwanted lines with the putty eraser.

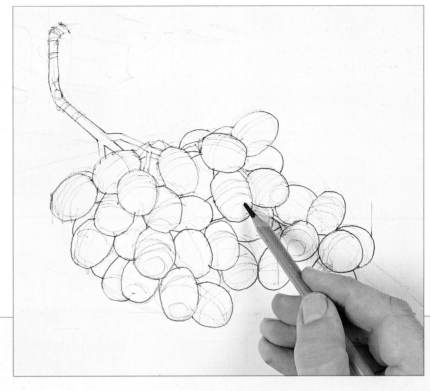

9 Having established the correct shape and proportion of your subject matter, you now have a very solid foundation on which to build.

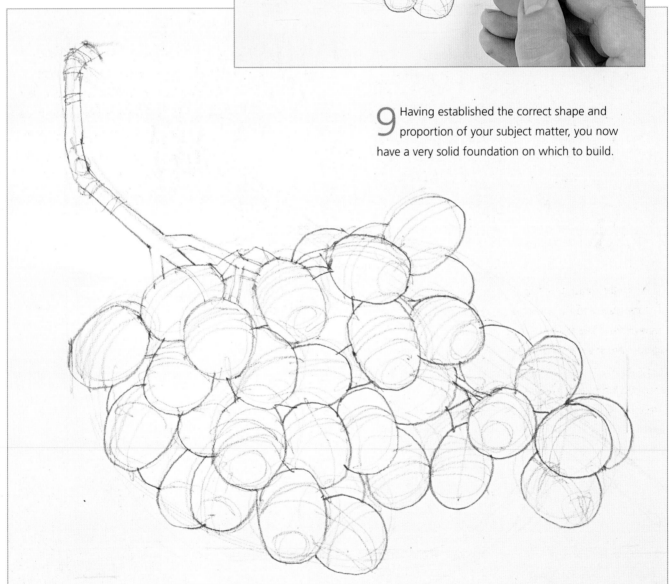

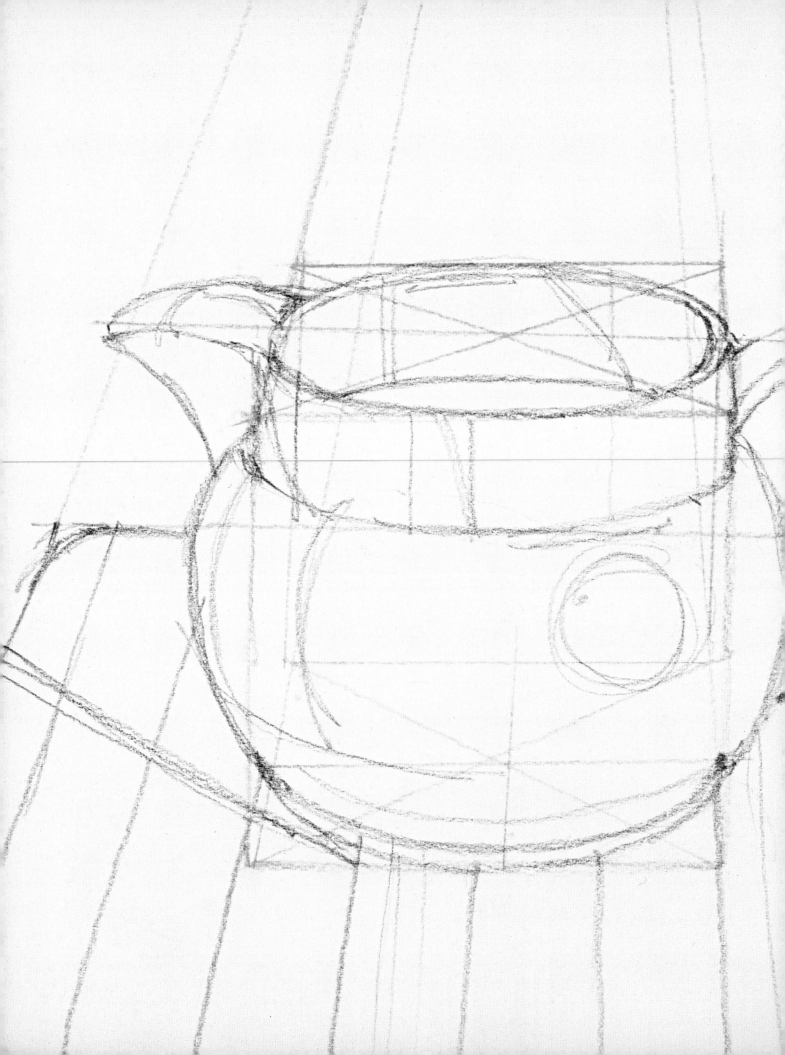

Step 2
perspective

focus: jug and board

Materials

White cartridge paper, 300 gsm/140 lb

Ruler (optional)

Artist's pencils

• *Black*

• *Terracotta*

Perspective is a device that enables the artist to make a convincing representation of three-dimensional subject matter on a flat, two-dimensional surface. Armed with a basic knowledge of perspective you can check whether a drawing is spatially correct. Furthermore, you will be able to overcome problems encountered when drawing awkward shapes, such as ellipses. Linear perspective may seem complex at first, but the basic rules are very easy to follow. By using perspective to orientate correctly the basic shapes that make up a subject – squares, circles and triangles (see page 21) – you can be certain that your drawn image corresponds with your subject and that its orientation is as it should be.

BASIC RULES OF PERSPECTIVE

The basic rules of perspective show that all lines running parallel to one another when seen on a receding plane meet at the same point in space known as the vanishing point. In simple perspective the vanishing point is always on a line that runs horizontally across the viewer's field of vision at eye level. All perspective lines that originate above eye level run down to meet the vanishing point, while lines that originate below eye level run up to meet it.

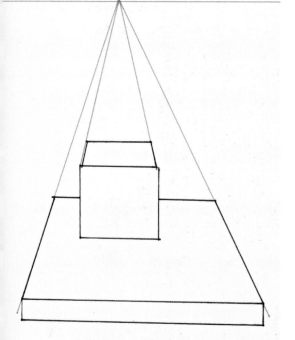

Single point: In this simplified diagrammatic drawing, the vanishing point of the chopping board and the cube are shown as one and the same.

SIMPLE SHAPES USING LINEAR PERSPECTIVE

Imagine looking down slightly, on to the top of a cube. Notice how, if the two sides of the cube's topmost surface are extended they meet at the same vanishing point. This is known as 'one-point' perspective. But if the cube is turned so that two sides and the top of the cube can be seen, the perspective changes. Extending the top and bottom lines of one side of the cube until they meet at their vanishing point gives the correct

perspective for that side of the cube. Repeating the process gives the perspective for the other side of the cube. Then joining up the two top edges to their respective vanishing points gives the top surface in perspective. This is known as 'two-point' perspective. When looking at several objects grouped together some may share vanishing points, while others will have their own, depending on their orientation.

You can draw the ellipses seen in cylindrical and cone-shaped objects in perspective by first drawing the shape as a cube. Divide the top and bottom of the cube using diagonals to find the centre of each side. Use these lines to plot the curve of the cylinder's top and bottom.

AERIAL PERSPECTIVE

There is one other type of perspective, known as 'aerial' perspective. This concerns the effects of the atmosphere and its influence on the landscape: not only do objects become smaller the further away they are, but they also become less distinct. It is a powerful tool that can make the difference between a good or bad drawing, and is achieved by making detail and textures less distinct, by reducing tonal contrast and by using cooler colours.

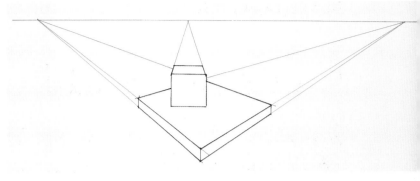

Multiple point: The orientation of the board is such that two edges can be seen rather than one, so the drawing requires three vanishing points: one for the cube representing the jug, and one for each side of the chopping board.

Creating depth: This sketch illustrates the basic rules of aerial perspective. The colours are cool in the background, where there is less contrast and less detail evident. Greater detail and warmer colours are seen in the foreground. The fence posts become smaller as they recede back in space.

DRAWING THE JUG AND BOARD

Although different in shape, both the jug and the chopping board in this exercise can be drawn using the same principles of linear perspective. The trick is to represent the round jug as a simple box in order to position it properly, in perspective, and with the correct orientation and volume. All distances can be judged either by eye or by taking a measurement.

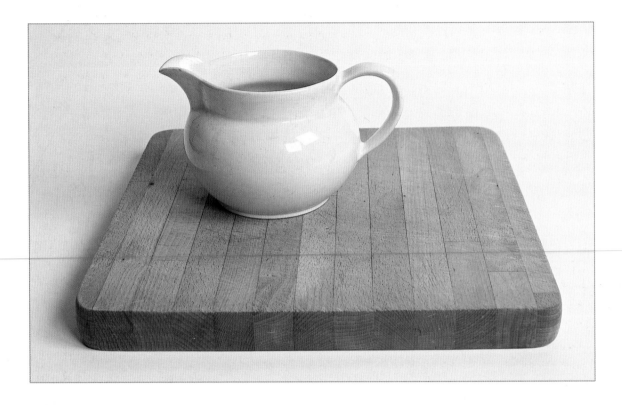

1 Very roughly establish the approximate position of your subject on the paper (see page 20), allowing enough room at the top for the extended perspective lines. Establish the depth of the chopping board by taking a vertical measurement and draw the front and back edges as two lines running parallel to one another using the terracotta pencil. Bear in mind that, quite often, the vanishing points for some or all of your perspective lines will end outside the picture area.

2 You now need to establish eye level, which runs across the field of view, parallel to the two lines already drawn. You can do this either by eye or by taking a measurement from the back edge of the chopping board to a position that is at your eye level. Hold your pencil up at an angle that matches the angle of the left-hand side of the chopping board. Mark the position and angle of this line on your drawing, extending it up to the eye-level line. Gauge the width of the board along its bottom edge, either by eye or by taking a measurement, and draw a line up from the right-hand corner so that it meets the eye-level line at the same point as the line marking the left-hand side of the board. Any other perspective lines used on the drawing, if extended to the eye-level line, must converge at this point.

3 You have drawn the surface of the board correctly in perspective. Now estimate and establish the thickness of the chopping board, and drop two vertical lines to indicate the two ends. Join these together with a horizontal line, and you should have a shape resembling a take-away pizza box.

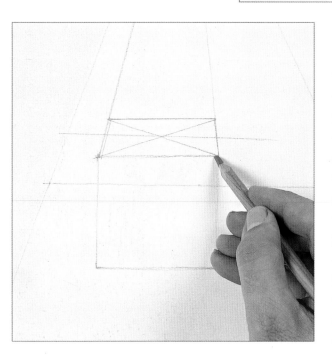

4 The next step is to draw a box, in perspective, that will serve as the foundation for the jug. Draw a horizontal line where the front edge of the bottom of the jug sits on the chopping board. Establish another horizontal line at the point where the front edge of the top of the jug rests. Now drop a vertical line to mark the position of the left-hand side of the jug and do the same for the right-hand side where the handle meets the bowl. You should now have a square. Extend a line from each top corner of the square up to the vanishing point. Estimate the depth of the jug's opening and draw a horizontal line joining the two lines just drawn. You should now have a drawing of a solid cube in perspective. Find the centre of the topmost surface of the cube by drawing in two diagonal lines that run from corner to corner. Run another horizontal line through the centre point to establish the axis of the handle and the spout.

5 By imagining that the cube is transparent, you can draw in its base by extending lines up from the front bottom corners to the vanishing point and then dropping verticals from the back two top corners. Draw a horizontal line where they meet to indicate the back rear edge of the cube. Find the centre of the cube's base by drawing in the diagonals. You can now draw the ellipse representing the open top of the jug in perspective, by marking a curved line that touches each centre point on the front, back and two sides of the top of the cube. The same can be done for the base of the jug, although it is only necessary to show the side nearest to you.

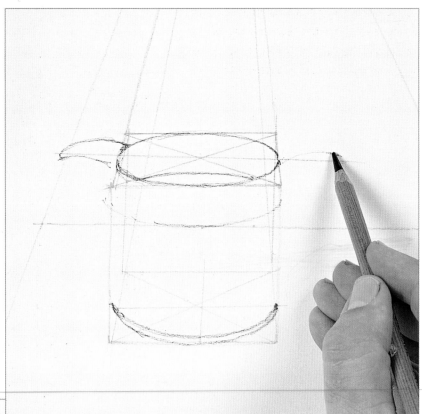

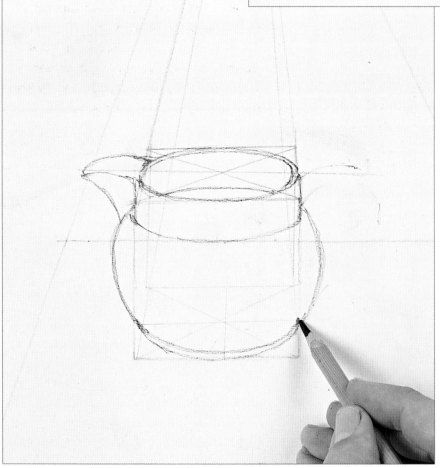

6 Draw in the spout and bowl of the jug carefully, by eye, taking care not to make it too fat. Measure the width if you wish, although it should be possible to judge the curvature by relating it to the vertical construction lines that represent the front edges of the cube.

7 Now draw the handle, using the negative shape between the bowl of the jug and the curve of the handle to assess the shape correctly (see page 21).

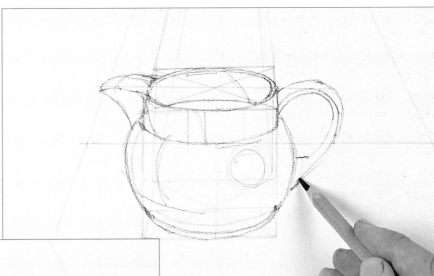

8 Draw in the curved edges at the front of the chopping board: notice how this changes the position of the end verticals. The chopping board is made from several pieces of wood that have been glued together in parallel strips. To show these in perspective simply draw the lines that separate them in such a way that, if they were extended, they would all converge at the vanishing point used for the rest of the drawing.

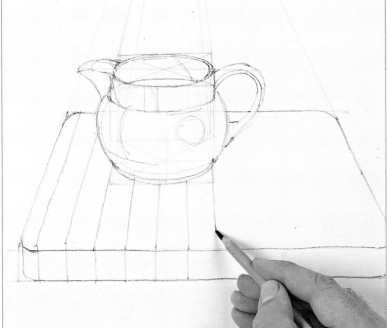

9 The finished drawing demonstrates how seemingly complex shapes can be rendered accurately by adhering to the basic rules of linear perspective.

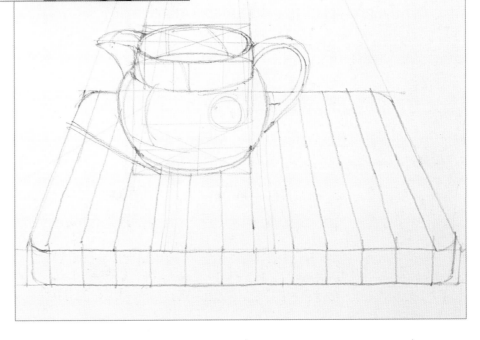

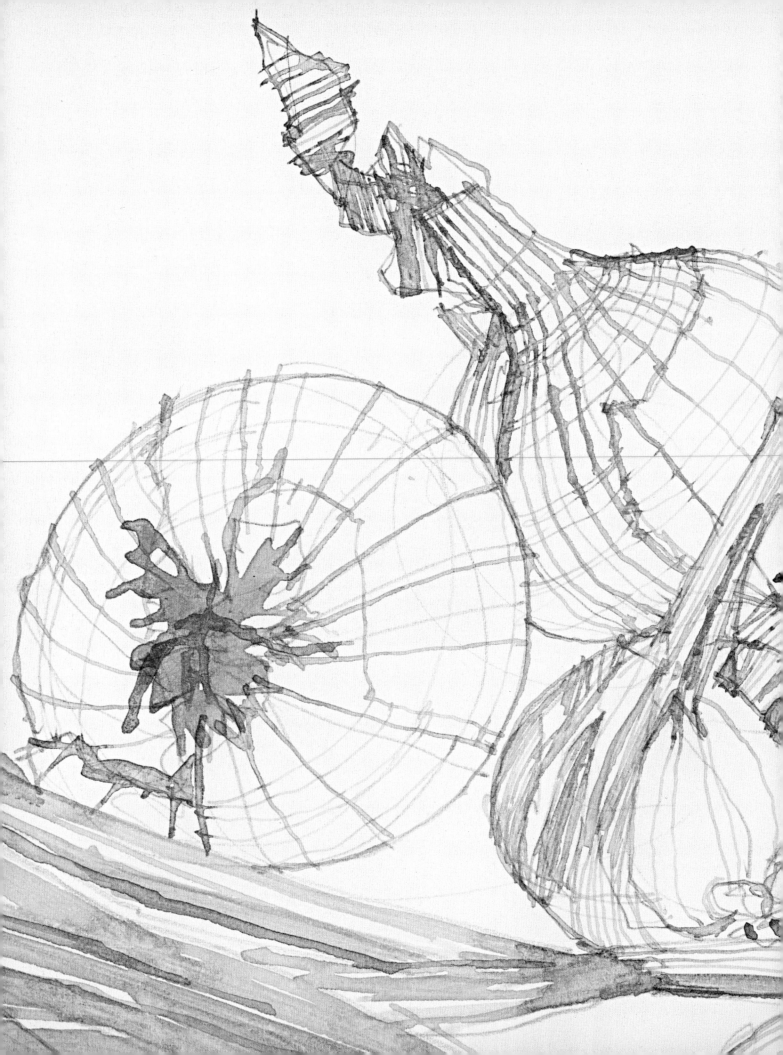

Step 3
line

focus: onions and garlic

Materials

White cartridge paper, 300 gsm, 140 lb

Sheet of scrap paper

2B graphite pencil

Dip pen

Medium steel nib

Reed Pen

Black Indian ink

Water

Putty eraser

Generally, all drawing tools render marks that are essentially linear. Even chalks (see page 13), which can produce large areas of uniform tone or colour, are used in the first instance to draw lines. The 'line' is a remarkable graphic invention, used for a variety of purposes, yet is something that is rarely given much thought. For example, how often do you doodle absent-mindedly with little consideration for what you are drawing? In the right hands, however, line becomes a powerful graphic device, showing not only the shape and form of something, but also hinting at the direction and quality of light, surface pattern and texture, even capturing movement.

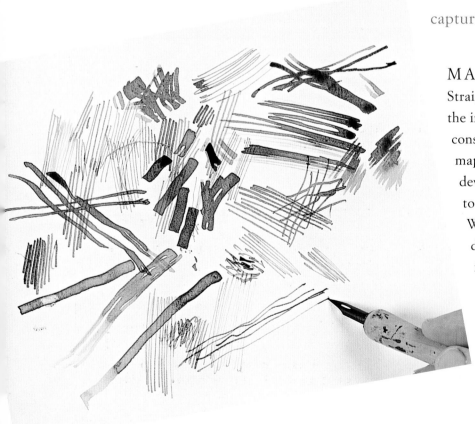

MAPPING OUT A DRAWING

Straightforward line work is very important in the initial stages of a drawing, as it is used to construct simple shapes (see pages 20–25), map out perspectives (see pages 28–33) and develop an underlying framework on which to 'hang' tone or colour (see pages 44–61). While this linear framework frequently disappears beneath subsequent work, finished drawings that leave the construction and layering exposed can have a beauty of their own.

Test your marks: As you work, use a sheet of scrap paper to test your marks. You will find this particularly helpful when working with pen and ink.

THE QUALITY OF LINE

Line quality can vary for a number of different reasons. Perhaps the most obvious is density: how light or dark a line appears. This depends on both the ease with which the drawing tool makes its mark and the pressure applied to the tool by the artist. Another consideration is line width. Drawing tools are usually sharpened to a point, which wears down as the line is made, depending on how soft the drawing material is. By varying the applied pressure and the angle at which the drawing tool makes contact with the paper, an experienced draughtsman can draw a continuous line that becomes both thicker or thinner and lighter or darker.

The speed and determination with which a line is made can also be used to good effect. A mark that is made slowly tends to appear hesitant and indecisive, while a line drawn quickly has a feeling of urgency and strength. Such techniques can be helpful when depicting the characteristics, or even the surface texture, of an object (see pages 64–69).

Varying line width: When using drawing materials like graphite, charcoal or chalk, the line width can be varied by altering the angle at which the drawing tool meets the paper. With practice, it becomes possible to alter the line width without pausing to change your grip. This results in fluid, unbroken line quality.

Linear variations

This example shows how charcoal has been used to draw six very different lines.

A line with a fast, fluid stroke that was made by keeping the hand rigid and moving the whole of the arm.

This line is bold and assured. The charcoal was held close to its point so that the maximum amount of pressure could be applied.

The stroke here is more hesitant. Its jerky nature comes from using the hand and the fingers to change direction constantly as the stroke was made.

A broken line, made by lifting and returning the charcoal to the paper mid stroke.

This line was made reasonably quickly with the charcoal held at a distance from its point, so that only the minimum pressure was applied.

Here, the charcoal was turned in the fingers to present more or less of it to the paper as the line was drawn. The line is fluid and varies in thickness.

DRAWING ONIONS AND GARLIC

Onions and garlic are ideal subjects for a drawing using line. The dry outer skins have pronounced linear markings that travel around the form acting as contour lines. Following these lines makes the subject relatively easy to draw.

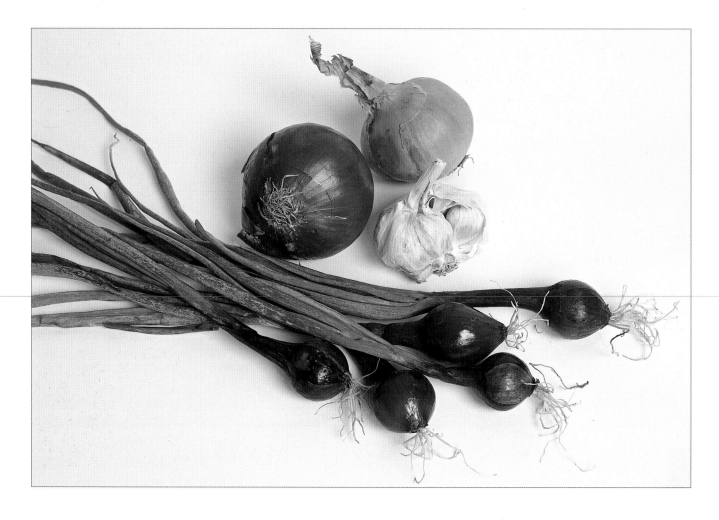

1 Draw, roughly, the shape and position of the onions and garlic using the 2B pencil, but avoid any detail at this stage (see pages 20–25). You can erase the soft pencil line later, once the ink has completely dried.

2 Use the pencil drawing as a guide to redraw the objects with the dip pen and ink. Many people find ink intimidating: it is a bold medium and more or less permanent. It may help to dilute your ink with water so that a paler, subtler line is produced. You can always use it at full strength in the later stages of the drawing.

3 Do not follow your pencil line slavishly, but use the ink to redraw the onions and garlic. Turn the pen as you make each line, applying more or less pressure to vary the thickness of the line. Use thicker lines in those areas that appear darker in tone or require emphasis.

4 As you work, explore the inner contours of each form, drawing the linear markings on the dry skin that follow each object's shape.

5 As your drawing builds up, vary the speed at which you work. Lines drawn quickly will appear more fluid and can be used to show the grace of the form, while lines that are drawn slowly look slightly jagged and help render cracked and broken skin.

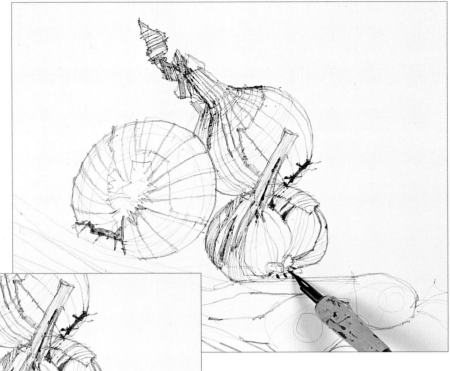

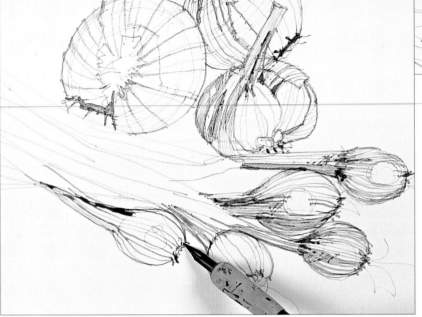

6 Create the richer tones by drawing your lines in closer proximity to one another, for example, on the small, dark spring onions where the linear patterning on the bulbs is particularly dense. Follow the contours of the bulbs.

7 Use the reed pen to draw the stems of the spring onions. This delivers a wider mark that breaks into two lines when the nib becomes splayed – perfect for capturing the stems. Draw the finer, less dense lines by turning the pen and using the edge of the nib.

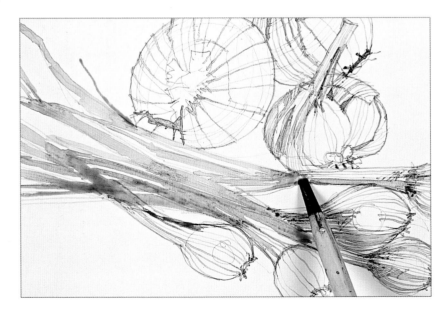

8 Use the same pen to draw in the thin, wiry roots of the spring onions. Use just the corner of the nib so that the line made is relatively thin, and vary direction constantly as you work. Allow the finished drawing to dry overnight before erasing any pencil lines.

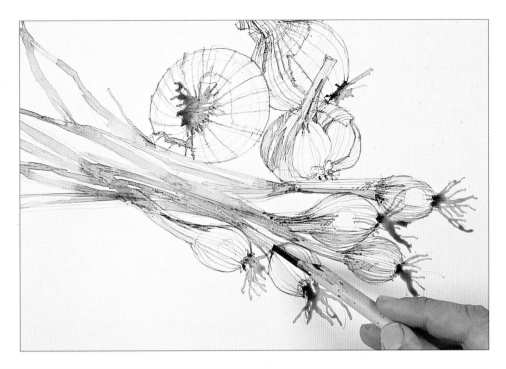

9 This relatively simple exercise shows how you can use linear marks alone to describe not just the shape and form of an object, but also its volume, tone and texture.

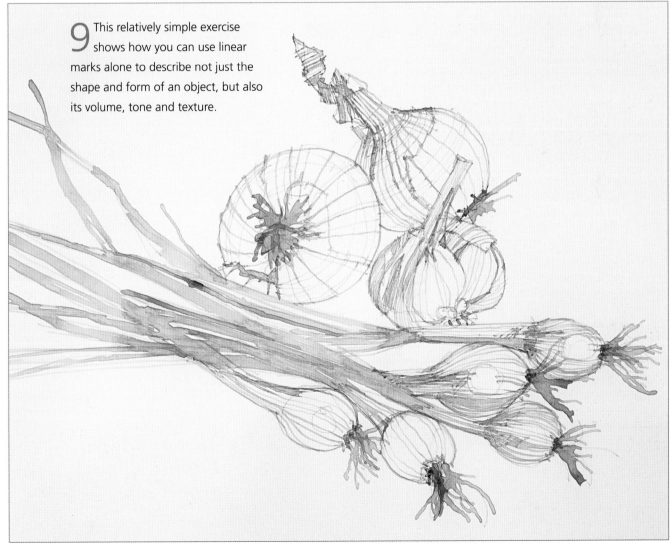

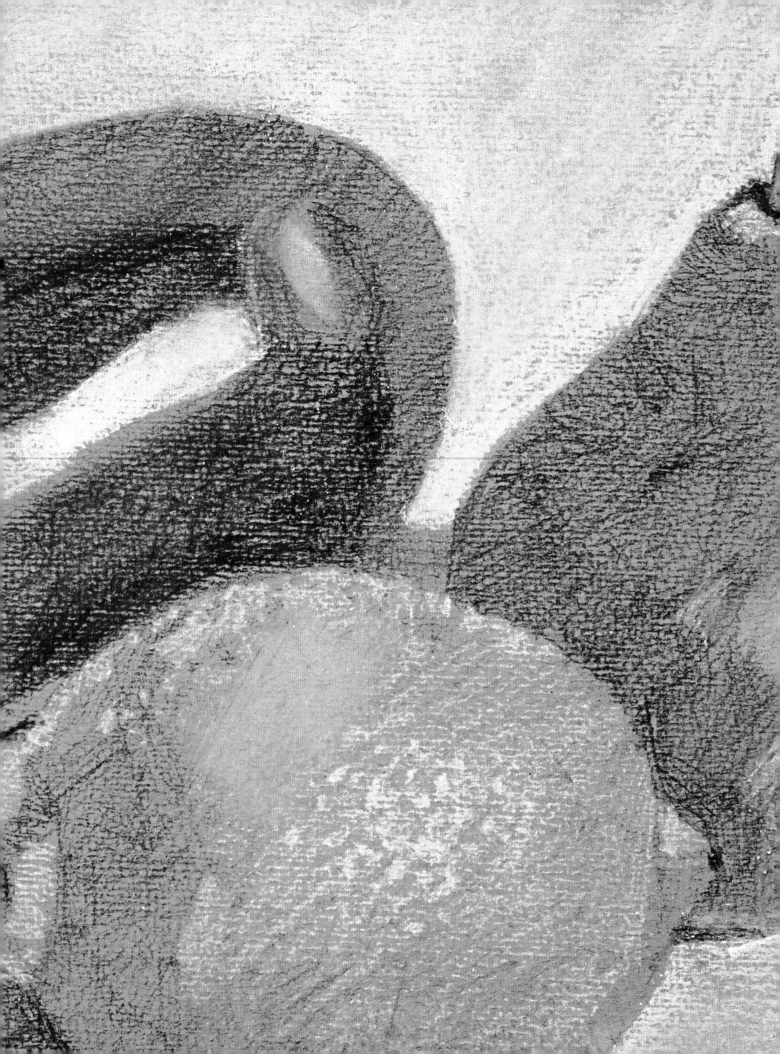

Step 4
tone

focus: aubergine, pear and lemon

Materials

Mid-grey pastel paper, 160 gsm/90 lb

Medium-sharp charcoal pencil

White chalk stick

Fixative

White pastel pencil

Blending stump

Tone is also known as 'value' and is an indication of the degree, direction and quality of light falling on an object. Variations in tone enable us to see the form and substance of something, and rendering the correct tonal sequence, or progression, is critical when it comes to making a drawing look realistic. Tone is sometimes referred to as 'light and shade' but in reality it is much more than this, because the relative dark or light of an area of tone is also profoundly affected by the colour of the object the light is falling on.

QUALITY

A tonal scale: On white paper, you can make all of the tonal variations using a black drawing tool. When the colour of the paper acts as the mid tone, however, you need a black drawing tool to make the darker values and a white drawing tool to make the lighter values.

Tonal values run from white through to deep black by degrees that run into thousands. We can only realistically perceive, and in turn use, a handful of these different values – try drawing a tonal scale that runs from deep black to pure white and you will have difficulty making more than ten successive steps. Indeed, it requires just three tonal values to make something appear three-dimensional: a light tone, a mid tone and a dark tone. When rendering tone, it is useful to remember that the contrasts between light and dark are greater in strong light, while in soft, even light, tones appear to be of a very similar intensity and predominantly from the middle of the tonal scale.

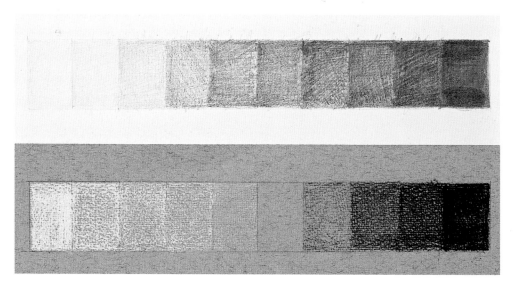

CREATING TONE

You can create tone in a number of different ways, depending on what drawing material you are using. With soft, dusty pigmented materials that smudge easily variations in tone can be achieved by pushing and blending the dusty pigment over the paper using a dry finger or a blending stump (see page 16). The technique, although successful, can result in drawings that look soft and bland.

You can also blend harder materials like graphite in this way, but you will have more success making tonal variations by altering the pressure you apply to the tool as you draw. With drawing materials like pen and ink, where the tool makes a mark that varies little, if at all, in width, you can build up tone using mark density – that is by drawing a series of hatched and crosshatched lines. Tonal variations can also be rendered using other marks, including dots or dashes. In practice, artists regularly use a variety of these methods in the same drawing.

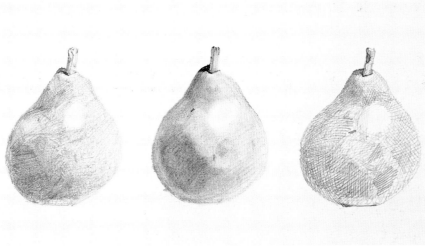

Three ways to create tone:
The pear on the left was drawn using graphite, applying a loose, scribbled hatching technique. The middle pear was drawn using charcoal and a smudging and blending technique. The pear on the right was drawn using dip pen and ink, together with a precise, crosshatching technique.

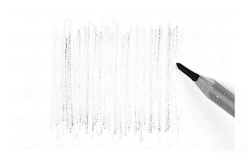

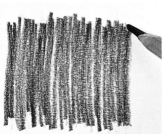

Creating variations in tone can take a little practice, especially when trying to render a gradual, almost imperceptible, transition from light to dark. You can make the task easier to some extent, by holding the drawing tool close to its point when making dark marks, and higher up the barrel when making lighter marks.

Light pressure: It is easier to create light tone by holding the drawing tool at a distance from its point.

Heavy pressure: To make darker tones, which require greater pressure, hold the drawing tool near its point.

TONAL TRANSITION

On angular objects with several different surfaces, the degree of tone alters significantly according to whether the surface faces more toward the light or away from it. On rounded surfaces the tonal transition is more gradual, with some surprising variations owing to reflected light from the surface on which the object rests.

DRAWING THE AUBERGINE, PEAR AND LEMON

For this exercise, an aubergine, a pear and a lemon are positioned on a sheet of grey paper. Each has a distinctly different colour to that of its neighbour. The tone values of each object are influenced not only by the quality of the light falling on it but by the intrinsic colour of the object and the white surface it is resting on. It is easier to judge the depth of tone required against a mid-tone paper than on white.

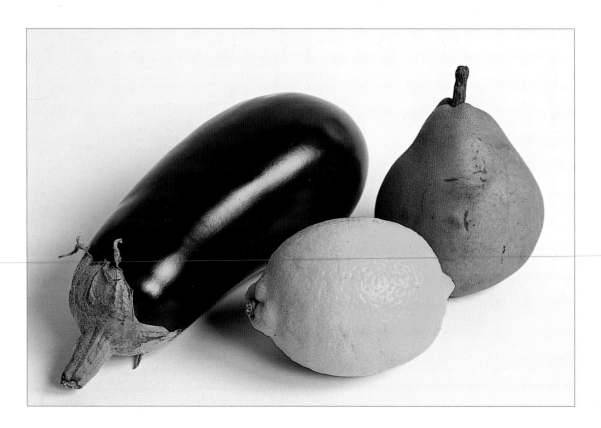

1 Using a medium-sharp, charcoal pencil, sketch in the position and basic shape of each object (see pages 20–25). Keep your line work fluid and light. Once you have established the shapes of the objects, mark on each the approximate points at which light tone turns to dark.

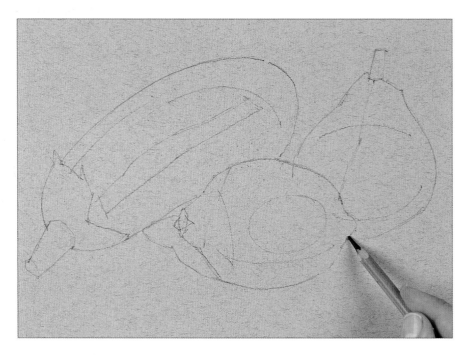

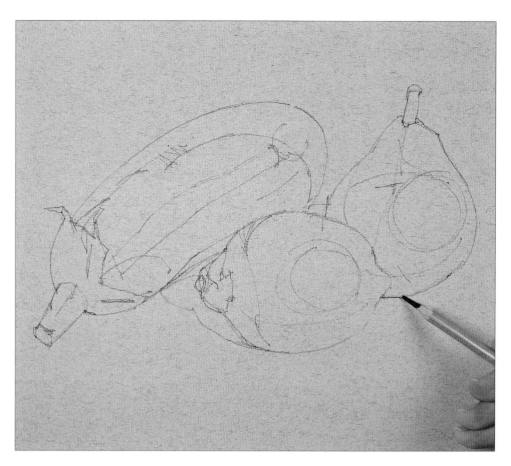

2 Still using simple line work, redraw the objects more carefully, correcting the shapes and giving more definition to the areas of shadow and highlight. Do not make the line work too dark at this stage.

3 Begin developing tone on the aubergine, stalk first followed by the dark mass of the fruit itself. Although the colour of the aubergine is very dark, notice how light the area of reflection is along its side and the strip of reflected light along its top. Remember when assessing tonal value that it is always easier to darken an area than it is to lighten it. Also bear in mind that the grey of the paper works as the mid tone against which all other tones need to be balanced.

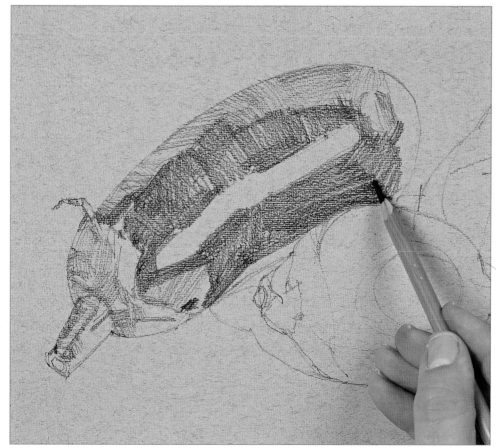

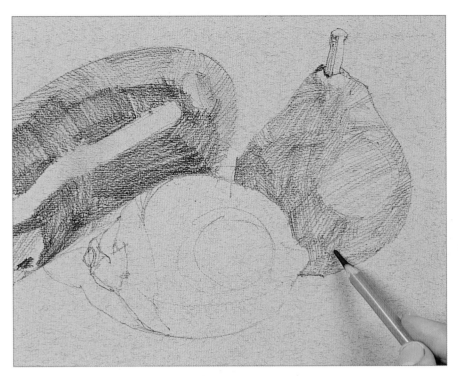

4 Turn your attention to the pear, which is a reasonably dark mid tone. Use a series of loose, scribbled crosshatched marks to portray the relative lights and darks. Notice how subtle changes in the tonal value indicate a change in surface orientation.

5 Now work on the lemon, which is the lightest of the three objects. Use the tones of the aubergine and pear to judge the values of the lemon. Differences are especially noticeable where the edge of one overlaps or butts up to another.

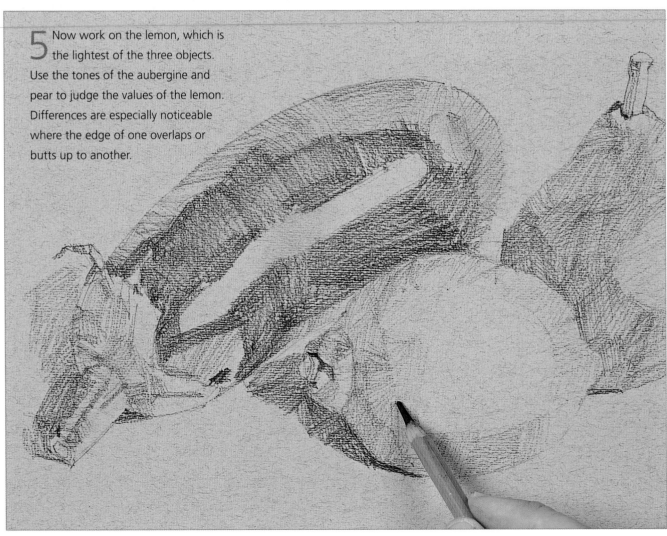

6 Use the side of the white chalk stick to block in the white background. Work up to the edges of the three objects carefully and leave the paper grey where there are cast shadows. The whole tonal balance changes immediately, with the values of the applied tone appearing darker now that they are read against a lighter background. You can apply a coat of fixative at this point to prevent your work from smudging.

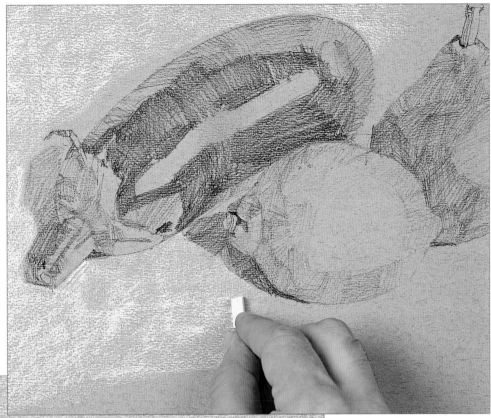

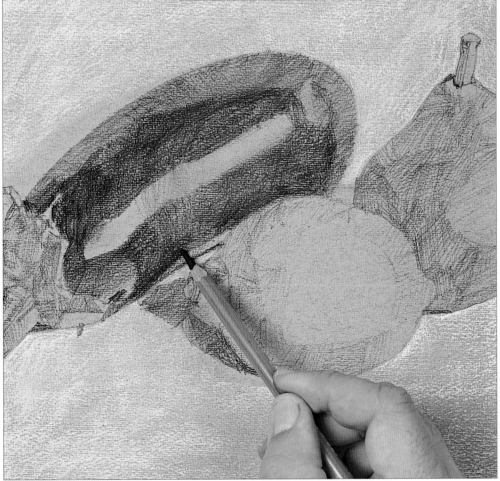

7 Reassess the tonal values of the objects. Here, it is clear that the aubergine is too light. Build up tone where necessary: by making the tones on the aubergine more dense, you can redefine the shape of the lemon, pushing it to the forefront of the composition.

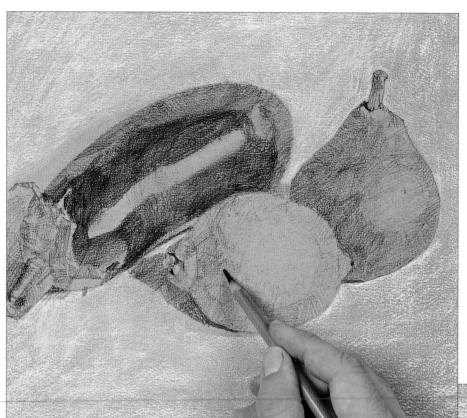

8 Revisit the areas of tone on the pear and the lemon and consider how you can improve the tonal values. Add tiny bits of detail as you go, in order to increase the illusion of realism.

9 Use the white chalk and the white pastel pencil, respectively, to draw in the highlights and to develop those tones that are lighter in value than the mid tone of the paper. Use light, crosshatched linear marks to achieve the more subtle tonal values, and apply more pressure to render the brightest highlights on the pitted lemon skin and the smooth aubergine.

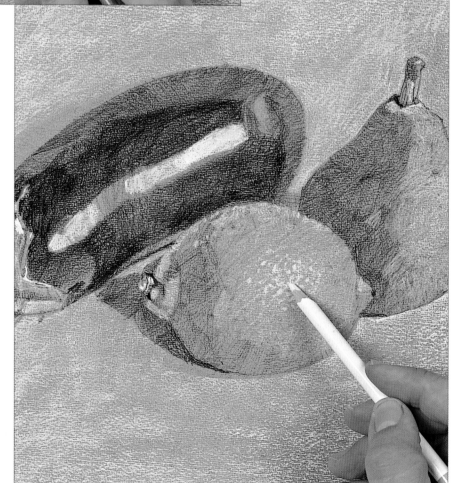

10 All that remains is to consolidate the white background, which you can do by applying more white chalk to the paper, and rubbing it into the surface firmly using a blending stump.

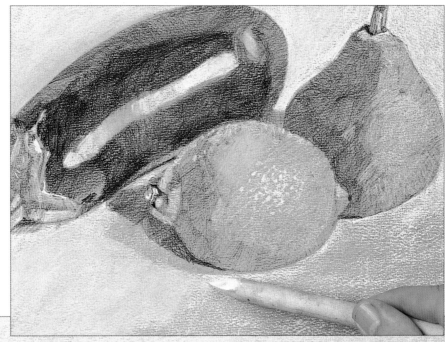

11 The finished image demonstrates how the tonal variations of each object are influenced not only by their own shape and colour, but also by the direction of light and the shadows they cast on each other.

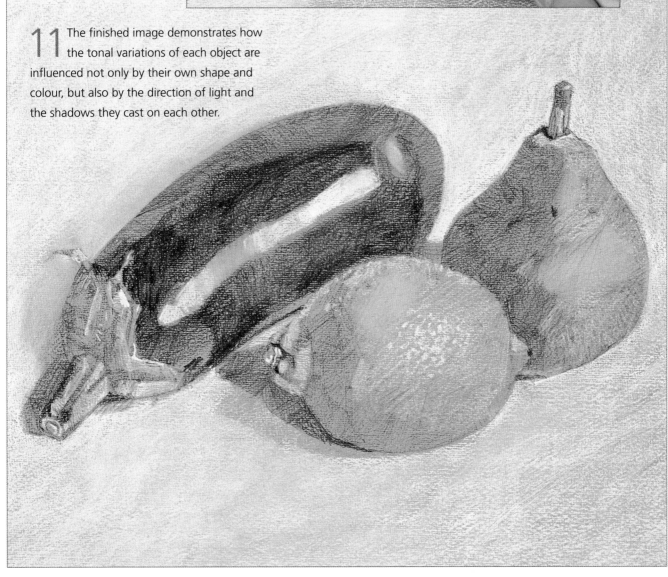

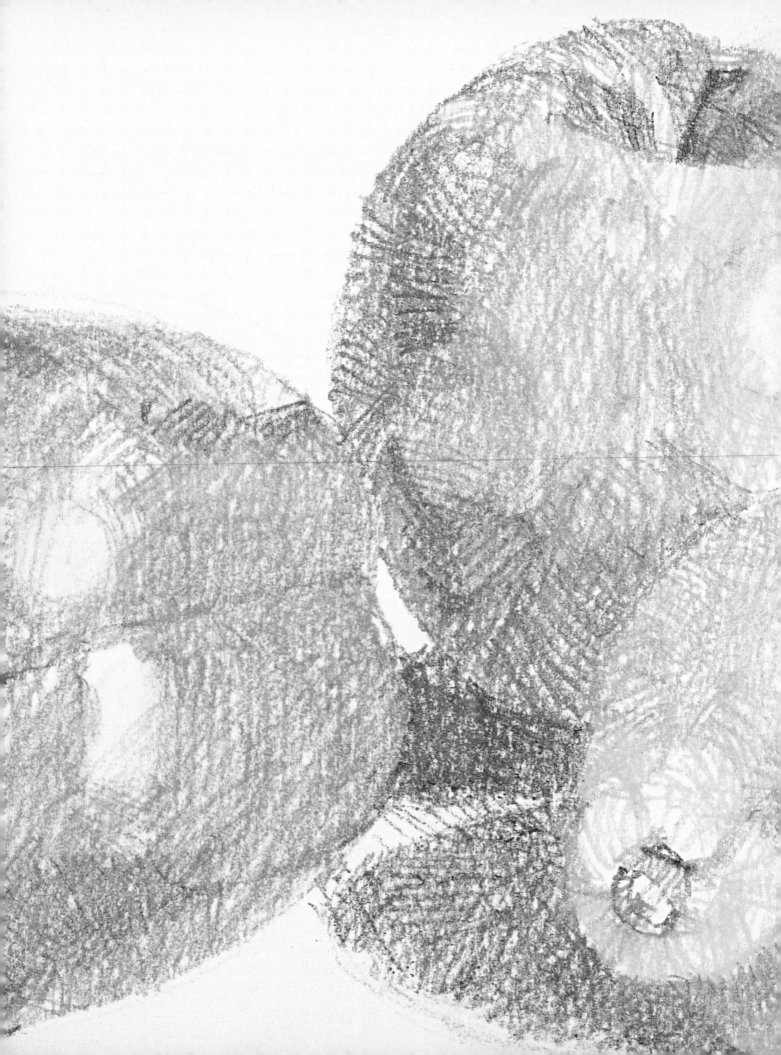

Step 5
colour

focus: apple, lemon and pepper

Materials

White cartridge paper, 300 gsm/140 lb

Pastel pencils:

- *Cadmium red*
- *Crimson*
- *Cadmium yellow*
- *Lemon yellow*
- *Yellow ochre*
- *Cadmium orange*
- *Mid green*
- *Light green*
- *Dark violet*
- *Indigo*
- *Ultramarine blue*
- *Dark grey*

Everything has an intrinsic colour, which is affected by the intensity and quality of the light falling on it. When it comes to representing colour in a drawing, much depends on the materials used. For the most part, drawing materials are both monochromatic and linear in application. Colour is introduced using some form of dry pigment such as chalk or coloured pencil, which differs distinctly from paint in that any mixing of colour takes place on the paper and not on a palette prior to application.

WHAT IS COLOUR?

Everything has colour, but it is necessary for light to fall on an object in order to see that colour. White light consists of the seven colours of the visible spectrum and is a form of electromagnetic radiation. The seven colours are red, orange, yellow, green, blue, indigo and violet. Each operates on a different electromagnetic wavelength. Every object absorbs a number of electromagnetic wavelengths, while reflecting others. We 'read' the reflected wavelengths as the colour of the object: a green field is perceived as being green because the green wavelengths are reflected while the others are absorbed. We see black when all of the wavelengths are absorbed, and white when all are reflected.

The light spectrum: The seven colours of the visible spectrum that make up white light.

Colour terminology

A distinct terminology is used when discussing colour, which, if learnt, makes a complicated subject much clearer and more easily understood. The most common terms relating to drawing and drawing materials are listed below.

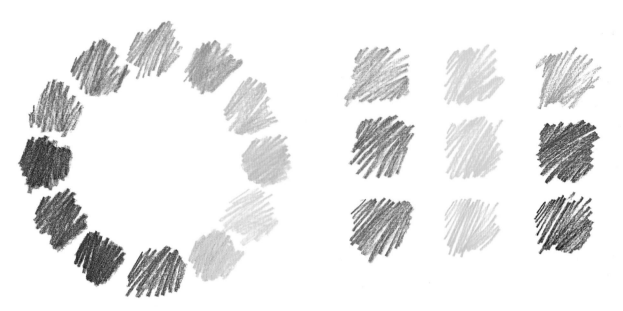

Colour wheel: The colour wheel presents colours in a circular sequence that corresponds to the order of spectrum colours that make up white light (see opposite). The device is useful for looking at, and making sense of, colour relationships.

Primary colours: Red, yellow and blue are primary colours. They cannot be made by mixing other colours.

Secondary colours: Mix together any two primary colours and the result is a secondary colour. Red and yellow make orange, yellow and blue make green and blue and red make violet.

Tertiary colours: Tertiary colours result from mixing a primary with the secondary colour next to it in equal measure.

Complementary colours: Complementary colours are those that fall opposite one another on the colour wheel. When placed next to each other they have the effect of making one another look brighter. The effect is very different when the colours are mixed together, however. This has a neutralizing effect on the colours and results in a range of greys and browns that echo the colours seen in nature.

Colour temperature: Colours are generally considered to be either warm or cool. Red, orange and yellow are considered warm, while green, blue and violet are considered cool.

Hue: Is simply another name for colour. Ultramarine, cerulean blue and cobalt blue are all hues albeit similar.

Value: Is a term used when discussing tone and describes the relative light or darkness of a colour. Yellow is light in value, while Prussian blue is dark in value.

Saturation: This describes the relative intensity of a colour. Colours that are similar in hue will have different intensities or brightness. Cadmium yellow is a highly saturated bright yellow while Naples yellow is not.

Harmony: Certain colours work better together than others, and are called harmonious. There are several different groups of these. Monochromatic harmony is achieved by using various tones of the same colour. Analogous harmony uses those groups of colours that are close together on the colour wheel. Complementary harmony is achieved by using groups of colours that appear opposite one another on the wheel.

A limited range: With a little practice you will discover how a seemingly limited range of coloured pencils can, in fact, become remarkably versatile.

USING COLOUR

In nature, pure brilliant hues are rarely seen: colours are invariably modified by other colours around them and can be difficult to pin down and mix. Getting the colour right can be a frustrating exercise. Although daunting at first, it is easy to see with the exercise that follows that remarkably few different coloured pencils are needed to produce a drawing. Trial and error when using coloured or pastel pencils will always produce results and it is advisable to try colour mixes and marks on a sheet of scrap paper before committing them to your drawing.

In this example, colour density has been achieved by increasing the pressure applied.

Here, the density is increased by building colour up in layers.

PRACTICAL CONSIDERATIONS

One of the main problems when using colour on drawings is how to build up the required density of colour without clogging the paper's surface texture with pigment. There are several different ways of solving the problem. The first is to work on coloured or tinted paper. This adds density to the colours you are using and makes them appear much brighter than they would if applied to a white paper. An alternative to tinted paper is to work reasonably lightly to begin with, until you are certain your colours are correct. Try to achieve your desired mixes in as few layers as possible.

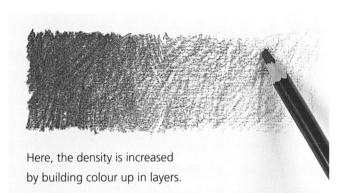

Paper colour: The colour paper you choose depends on your subject, but has the added advantage of creating a distinct mood and binds everything together creating a colour harmony.

DRAWING THE APPLE, LEMON AND PEPPER

These three objects have been chosen for their strong individual colour and the reflective qualities of their skin. The colour of each is influenced not only by its actual surroundings and the light source but by the reflected colours of the other fruit.

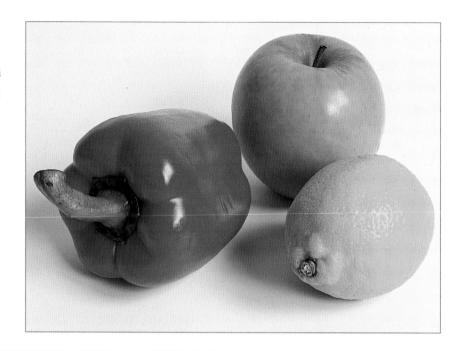

1 Begin by sketching the general shape of each object. This is to position the objects in relation to one another (see pages 20–25). These lines will be covered by subsequent work so draw lightly at this stage. Choose colours that correspond roughly to the colours of the objects: cadmium red for the pepper, a mid green for the apple and cadmium yellow for the lemon.

2 Use this light sketch as a guide to redraw the objects, refining and correcting the shapes as you work. Seek out areas of shadow and changes in colour and tone: use a simple line to define these areas (see pages 36–41). Pick out the highlights in the same way. Use an indigo pencil to outline the shapes made by the cast shadows. See, here, how the area of reflected colour from the red pepper has been defined on the apple and the lemon.

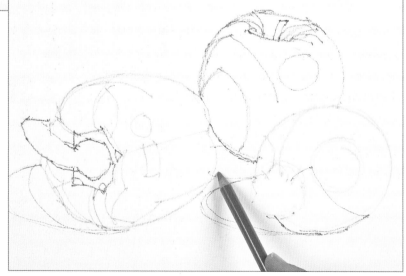

3 Turn your attention to the pepper. Use the cadmium-red pencil to block in and establish its overall colour. Do this by seeking out the contours of the pepper's form and use a series of directional strokes that follow those contours (see pages 36–41). Do not make the colour too dense at this stage. Leave any highlights showing as white paper.

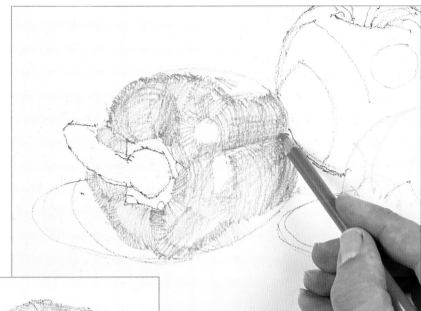

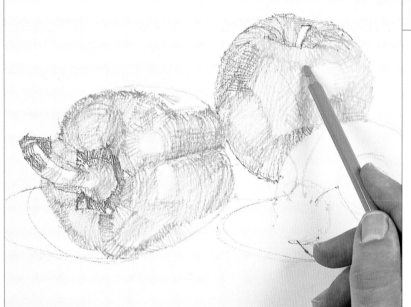

4 Continue this process with the pepper stalk and the apple – making strokes that follow the contours of each. Use the mid green to colour the darker areas and progress to a lemon yellow for the lit side of the fruit. Overlay the yellow with soft strokes of light green. Use cadmium red for the reflected colour of the pepper and yellow ochre for the brown markings around the stalk. If an area appears too dark or overworked smudge it gently with a finger to remove some of the pigment and rework it.

5 Now work on the lemon. Use cadmium orange to fill the area of reflected colour from the pepper. Use yellow ochre where the lemon is in shadow and cadmium yellow to establish the colour of the rest of the lemon. As before, leave the highlights as white paper.

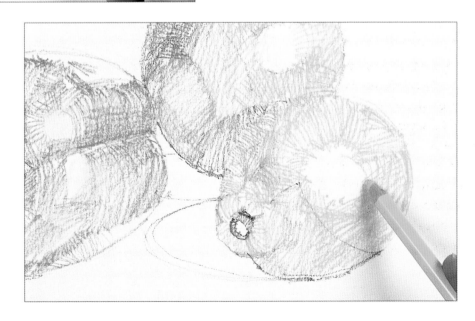

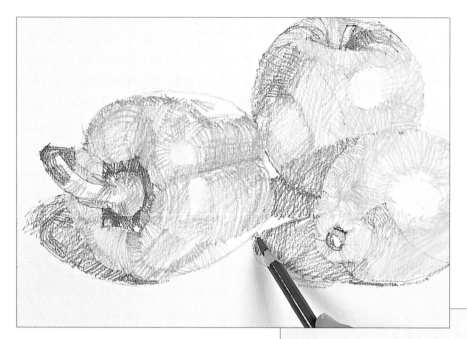

6 Start to add to the shadow areas. Use a dark grey for the main areas of shadow cast on to the white surface. You will modify this shadow later using additional colours, so do not be tempted to make it too dark. Use the same grey to add a darker tone to the shadow areas on the apple and lemon.

7 Now return to your subject. Use cadmium red to consolidate the overall colour of the pepper, still working in strokes that follow the contours. Use a darker, crimson pencil to intensify the colour in the areas of shadow, and a dark violet for the darkest shadows. Rework the side of the pepper facing the light, using a cadmium orange pencil to increase the depth of colour.

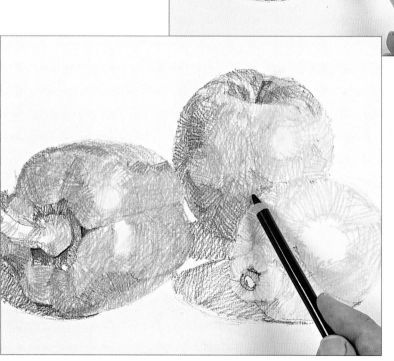

8 Rework the apple in the same way. Add more cadmium red to the area of reflected colour and overwork this using the mid green. Apply lemon yellow to the side facing the light and use indigo to darken the shadow cast by the lemon.

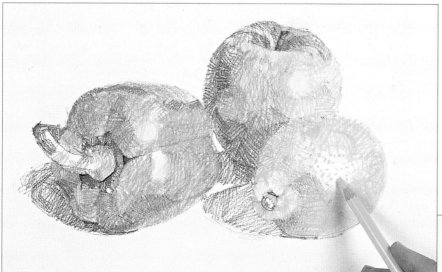

9 Deepen the colour of the lemon using cadmium orange and yellow ochre. Carefully apply a little light green to the belly of the fruit and pick out the mottled texture of the skin using cadmium yellow.

10 Return to the shadows cast on the white paper. Carefully crosshatch over the grey using the same colours as you used for each object: red on the shadow cast by the pepper, for example. To complete the effect, introduce a cool luminosity to the area with the addition of ultramarine blue.

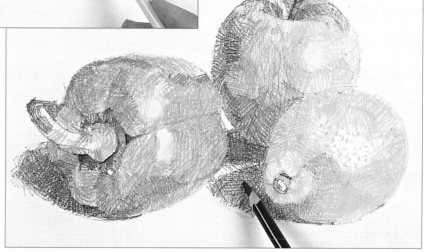

11 The finished drawing demonstrates that a complex range of colours can be produced by building up layers using a relatively limited palette.

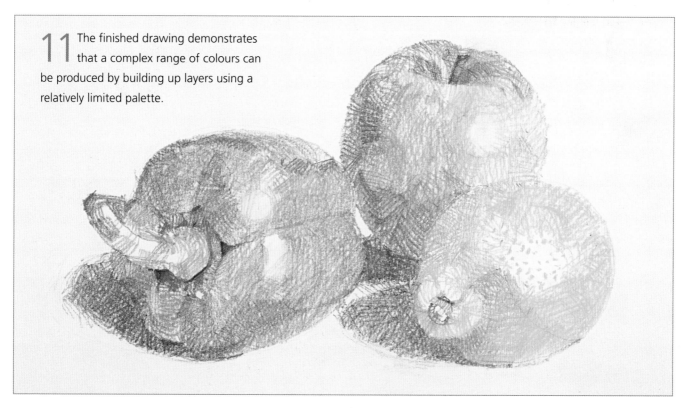

Step 6
texture

focus: pepper, courgette and melon

Materials

White cartridge paper, 300 gsm/140 lb

2B graphite pencil

Putty eraser

Every surface has a texture, which, in most cases reveals more information about the form of an object – soft and smooth, hard and spiky, rough and dry. Rendering texture accurately in a drawing can be challenging and requires a certain degree of experimentation and invention. Instead of trying slavishly to draw texture as it actually appears, you are more likely to find success in devising marks and techniques that give an 'impression' of the texture.

TECHNIQUES

In order to make convincing textural marks you need to know what your chosen drawing tool is capable of, and you will only find this out by experimenting. Take a sheet of scrap paper and fill it with different textural marks. See what happens when you alter the pressure or the way in which you hold the drawing tool. Attack the paper aggressively or make gentle tentative marks. Try using different shaped drawing tools.

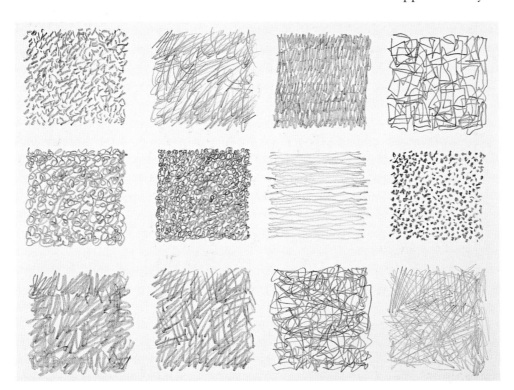

Textural marks: The full range of textural marks that you can make is determined only by your inventiveness. By using a range of different shaped drawing tools, a variety of speeds and altering the pressure when making marks, you will broaden your repertoire further.

DRAWING SURFACES

The texture of your drawing surface is important. A specific style of mark made on a smooth surface will look different when made on a rough surface, so it's important to choose a paper with qualities that will contribute to the drawn image. However, bear in mind the drawing material you are using: you will find it difficult to render a dip-pen drawing on very rough paper or to use charcoal on a very smooth surface.

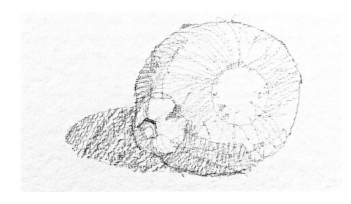

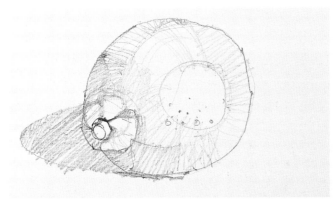

Choosing papers: When drawing objects with texture your paper choice can be important. Opting for a rough paper for a rough textured subject will save time and produce a better result.

WORKING IN LAYERS

It is not always possible to create the textural effect you want in one layer. By working in two or more layers you can build up the density of a texture. In order to do this you may need to apply fixative between the layers. Without fixative, friable drawing materials, such as charcoal or chalk, build up but do not adhere to the surface and are easily smudged.

ERASING

Erasers can be very useful when creating texture in a drawing. They make it possible to work back into areas of tone revealing the paper surface and creating linear or textural marks that have a completely different quality to marks made using pigment or the drawing tool itself. The melon in this exercise is a good example of this. Consider the light textures and patterns on the surface of the melon. If using the drawing tool alone, you would have to work around the lighter areas in order to render them accurately. By using an eraser you can apply tone to the entire surface of the melon and can 'rub' in the lighter textures and patterns with the eraser.

Soft erasers: You can mould soft putty erasers into shape. They are best used on materials like graphite, but can become dirty very quickly.

Hard erasers: Harder, vinyl and plastic erasers do not become dirty quite so fast and make crisp precise lines. They can easily be cut into a range of shapes.

DRAWING THE PEPPER, COURGETTE AND MELON

The objects chosen for this exercise all have textured or patterned surfaces typical of many fruits and vegetables. Unlike man-made patterns, natural patterns and textures tend to be more random and it can be a challenge to render them in an interesting way.

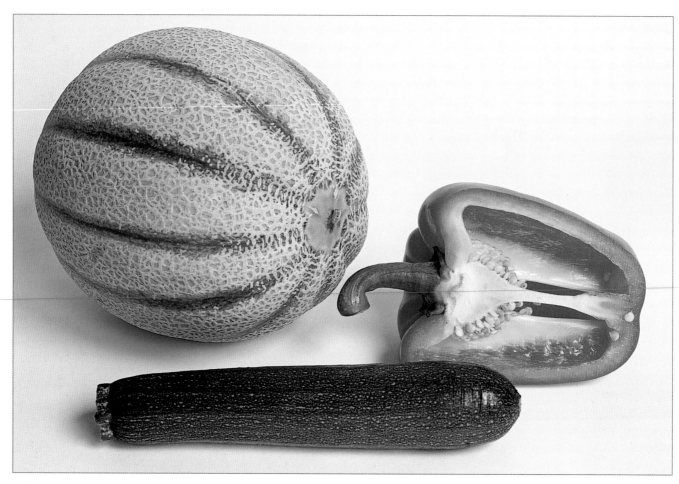

1 Rough out the shape and position of each object using fluid, loose line work. Concentrate on getting the initial shapes right at this stage (see pages 20–25).

2 Redraw using the rough shapes as a guide, and seeking out any linear marks that can be made: notice how these give a clue to the form of each object by following the contours – for example, the dark ridges on the melon.

3 Add tone to the dark ridges of the melon, using reasonably firm pressure and varying the direction of the scribbled marks. Fill in the overall tone of the melon, again using multi-directional, scribbled marks but do not attempt to draw in any pattern or texture at this stage.

4 Once the tones are correct use a corner of the putty eraser to work back into these tonal areas. Use a jerky scribbling motion that best describes the surface of the melon.

5 You can now use the pencil to apply
pattern. Darken sections on the
surface of the melon, using the light
tracery made by the eraser as a guide.

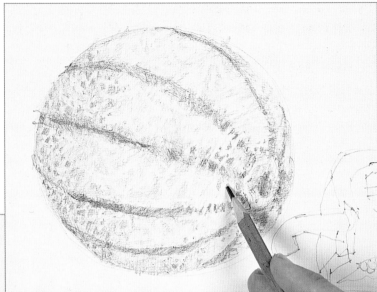

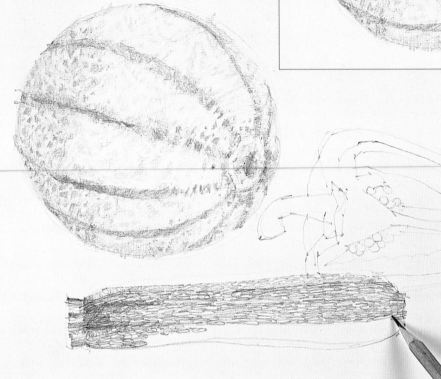

6 Draw in the pattern on the
short stem of the courgette. To
convey the texture of the body, use
a circular scribbling motion to make
a series of elongated oval marks
over its entire length.

7 Draw the stem of the pepper
using linear marks that describe
the striations running down the
curved stalk. The outside skin of the
pepper is smooth and reflective so
apply overall tone that follows the
curves of the contours. The internal
walls of the pepper have a uniform
pitted surface, which you can
render by using a heavy, circular
scribbling motion.

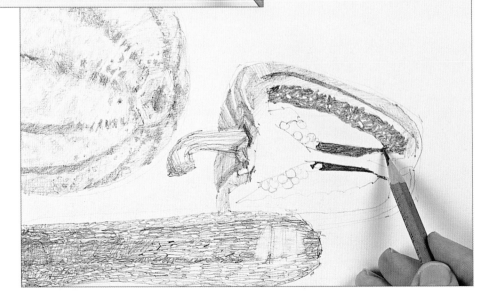

8 Now draw the dark areas between and around the seeds and apply less pressure to make a series of elongated oval marks capturing the lighter internal texture of the pepper. Draw the cut surfaces by making directional strokes that follow the object's shape.

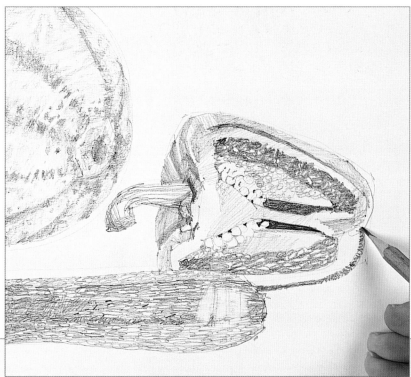

9 You can see from the finished drawing that it is possible to create a wide range of textures using a number of different drawing techniques.

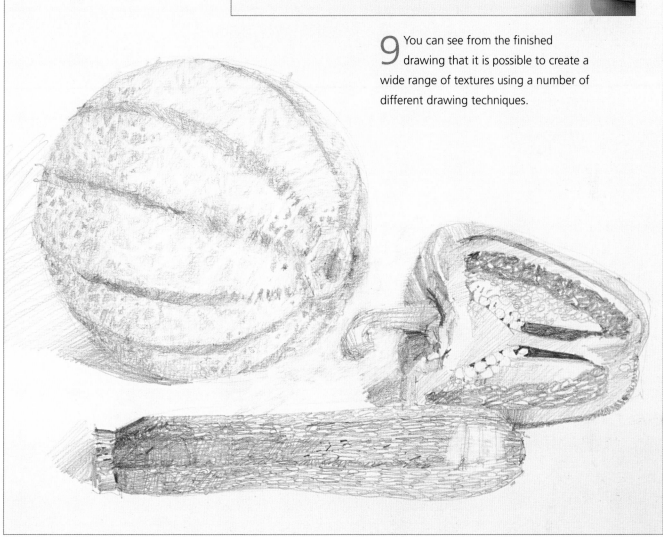

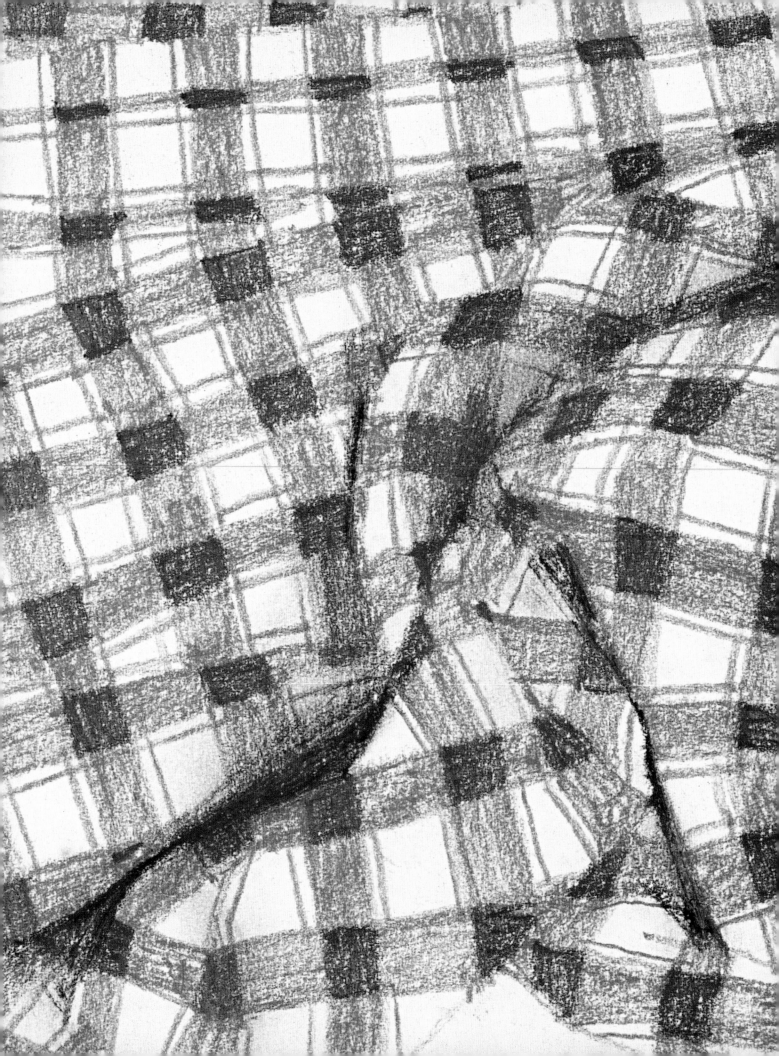

Step 7
pattern

focus: checked cloth

Materials

White cartridge paper, 300 gsm/140 lb

Lead holder

Drawing leads:
- *Terracotta*
- *Sepia*
- *Black*

Capturing the pattern of an object can be a powerful way of describing its form. An object may have a very regular and repetitive pattern when seen 'flat', but which changes dramatically when seen from an angle or distorted in some way. This is particularly true of a pattern printed on, say, fabric or paper that has been draped over a three-dimensional object. Consider the checked cloth in this exercise: the patterned surface is two-dimensional when flat, but becomes distorted in such a way that the form of the underlying three-dimensional object – in this case an orange – can be 'read'.

CAREFUL OBSERVATION

In order to capture the effect on the surface pattern of one object that has been draped over another, it needs to be drawn quite carefully. In this exercise, there is a chance that the drawing as a whole will become confused and the viewer will be unable to read the shape of the orange beneath the cloth.

SUBTLE CHANGES

Often, changes in pattern are very subtle, yet there can still be sufficient change in direction for you to 'read' the situation. Repeated and geometric patterns work best, as a change in the uniform, grid-like appearance of the pattern is quickly noted. Linear patterns and checks are particularly good. Abstract and random patterns work less well, because the design shapes are often unfamiliar and it can be difficult to assess whether a distortion is due to a change in direction or is part of the design itself.

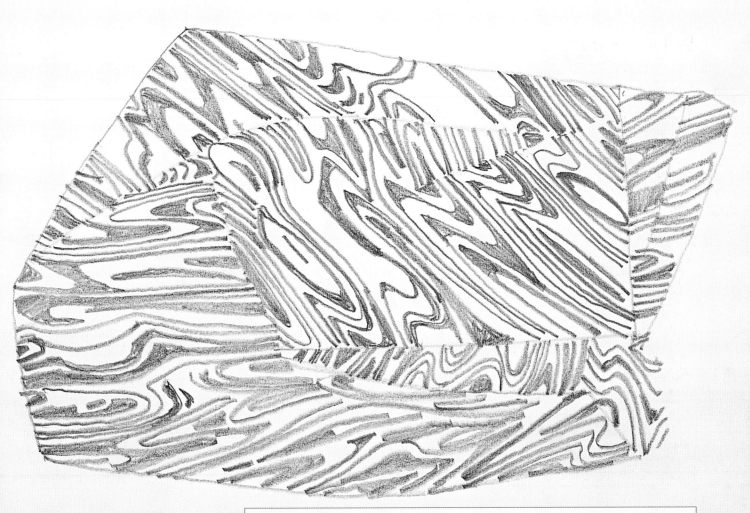

Distortion: It is difficult to read distortion on fabrics that have an abstract or random pattern.

Pattern: The shape of a pattern or motif alters as it follows the contours of an object, and enables the shape of that object to be read.

DRAWING THE CHECKED CLOTH

The check-patterned cloth used in this exercise is draped over an orange.
The intention is to show how the distorted pattern reveals the folds in
the fabric, but also gives clues as to the shape of what lies beneath.

1 Use the terracotta lead to
draw in the overall shape
of the cloth using simple line
work (see pages 36–41). Keep
the line light: these leads can
be difficult to erase and using
a light line at this stage allows
you to cover up any mistakes
with subsequent work.

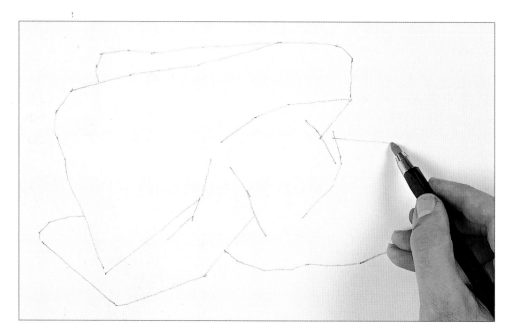

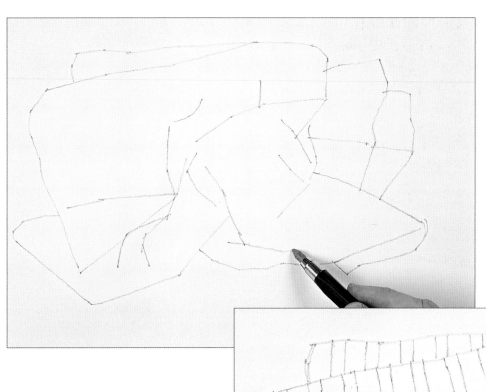

2 Develop the form further by seeking out the shape and direction of any edges made by creases or folds in the fabric.

3 Begin to draw in the pattern. Observe this carefully, drawing the lines in one direction first. Notice how the pattern, which in reality consists of lines that are equal in width, now has lines that vary in width quite considerably as they follow the contours of the draped cloth.

4 Now add the lines running in the opposite direction. Make sure that, where the cloth lies on a relatively flat surface, the lines cross at right angles to one another and form relatively even squares.

5 Once the linear pattern looks correct, you can block in the main bands of pattern with scribbled marks, still using the terracotta lead.

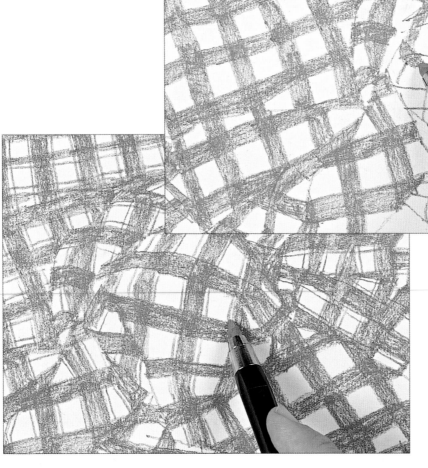

6 Now complete the thinner lines of the checked pattern. As before, pay careful attention to how these lines relate to each other and the folds of the cloth.

7 Use the sepia lead to darken the squares of the check. Draw each one carefully, as many of them will have become distorted by the movement of the cloth.

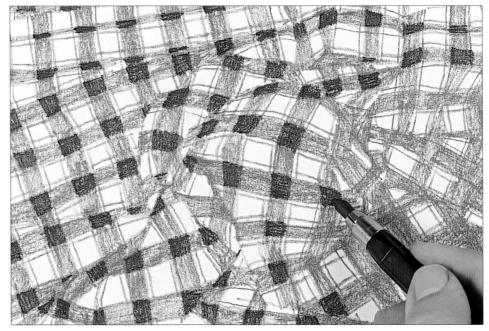

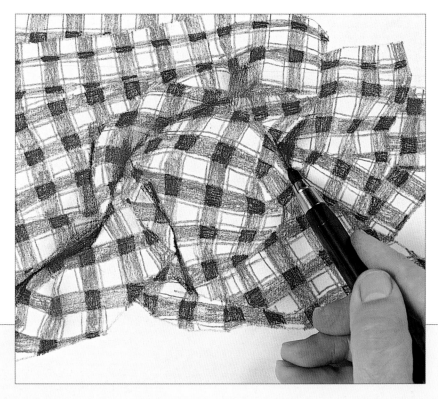

8 Now use the black lead to scribble in dark tone, deep within the tight creases and folds of the cloth, giving more definition to the form of the orange below.

9 The finished drawing simply demonstrates that it is essential for the distorted pattern of the cloth to be rendered accurately, in order to read the form that lies beneath.

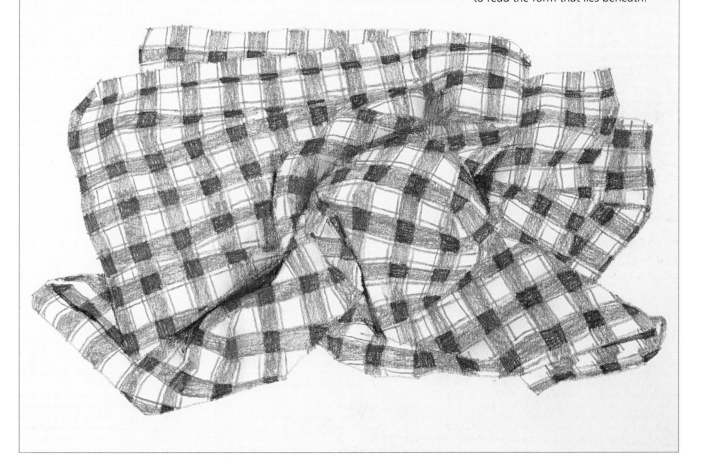

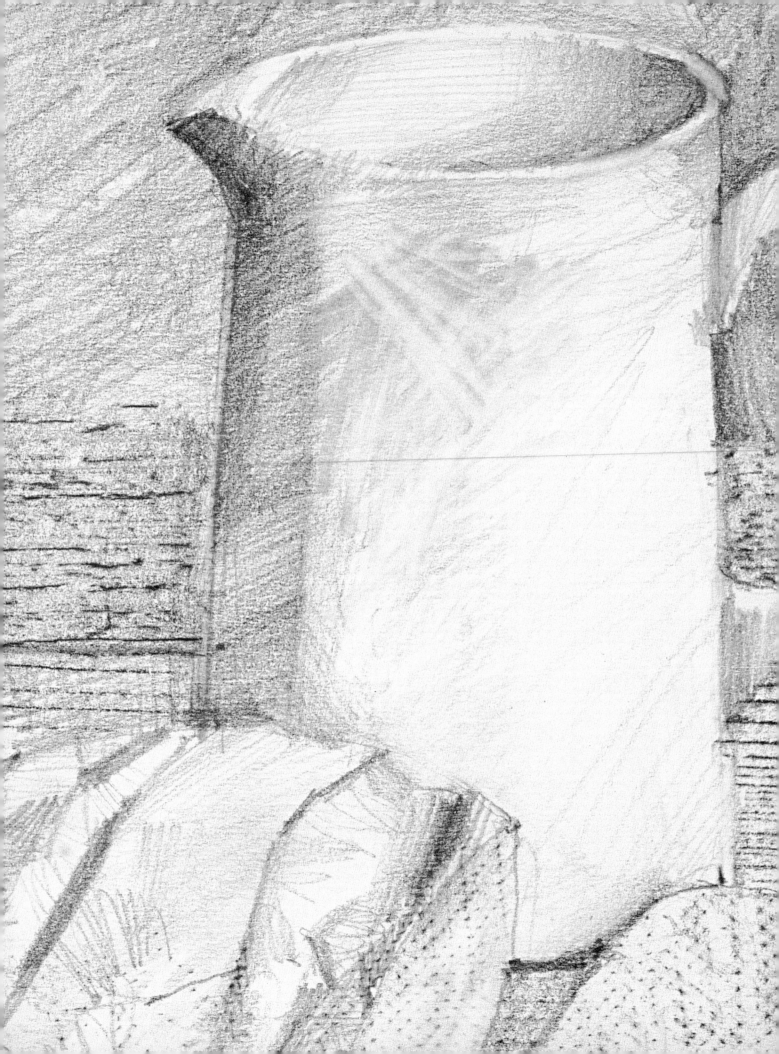

Step 8

advanced techniques

focus: jug, bread and knife

Materials

White cartridge paper, 120 gsm/60 lb

3B graphite stick

2B thick graphite stick

Putty eraser

Ruler

Sheet of scrap paper

Canvas board

Rough wooden board

There are several drawing techniques that, although not necessarily traditional, are nevertheless fun to use. Some of them work better with certain drawing materials than with others. They will bring a different quality to your work and, in some instances, may help turn a pedestrian drawing into something much more exciting.

MASKING

Applying tone up to an edge or line requires a certain degree of control to prevent marks going into an area where they are not wanted. In many cases, this means that you are working very slowly and using the drawing tool in such a way that the marks you make run parallel to the edge rather than at an angle to it. This can result in a rather drab 'filled in' look. By using a mask, made either from paper or card that has been cut or torn to shape, you can draw freely up to, and if necessary, over the mask to achieve the effect you want.

Using a mask: A sheet of torn or cut paper can be used as a mask in order to create a distinctive edge quality to an area of tone or texture.

FROTTAGE

Taken from the Italian word meaning 'to rub', this is a useful technique for creating textural effects. The effect is achieved by placing the paper – which needs to be relatively thin – over a hard, textured surface – say brick, old wooden floorboards, wire mesh or coarse fabric. When you draw on the paper, you pick up the texture of the surface below.

Quick textures: This drawing surface has been placed over a canvas board in order to create a frottage effect.

SGRAFFITO

Taken from the Italian word meaning 'to scratch', this technique involves scratching through layers of pigment using a sharp tool, in order to reveal either the original drawing surface – or a previously applied layer of pigment – beneath. The technique works best with dense, heavily pigmented tools, such as charcoal and chalk, which leave a relatively thick physical layer of pigment on the paper.

Scraping away pigment: Powdery, pigmented drawing materials can be scraped into, as can dry marks that have been made using ink.

DRAWING THE JUG, BREAD AND KNIFE

The very different textures of the objects in this exercise present specific representational problems. The advanced techniques used here offer possible solutions. However, be aware that frottage techniques can only be used successfully on thin paper.

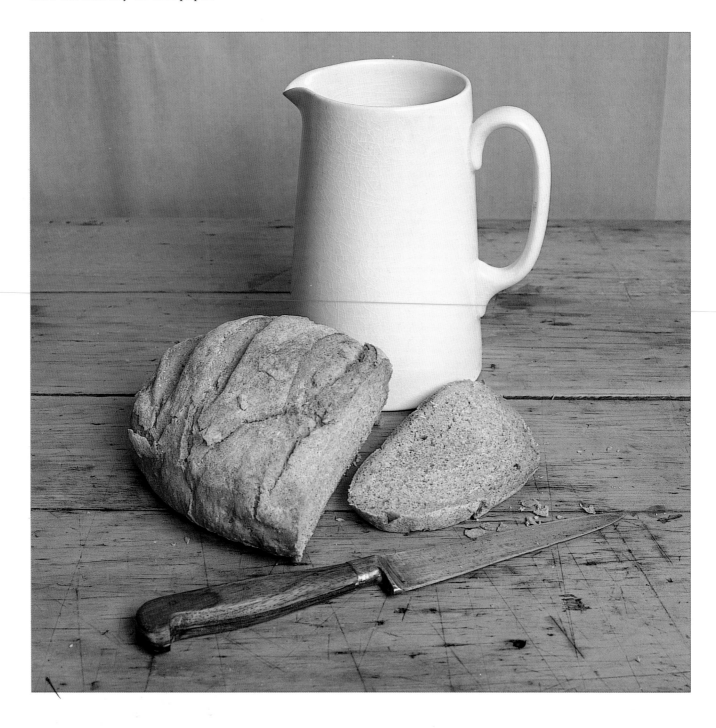

1 Sketch out the shape and position of each object in the group using the 3B graphite stick and a light line (see pages 20–25).

2 Redraw the shapes, developing and refining them as you work. Avoid adding any detail at this stage, as much of that will be provided by the techniques you use later.

3 Still using the 3B graphite stick, begin to develop the light and medium tonal values seen on the white jug (see pages 44–51). Hold the stick high up the barrel to help you apply the light pressure needed to make the marks.

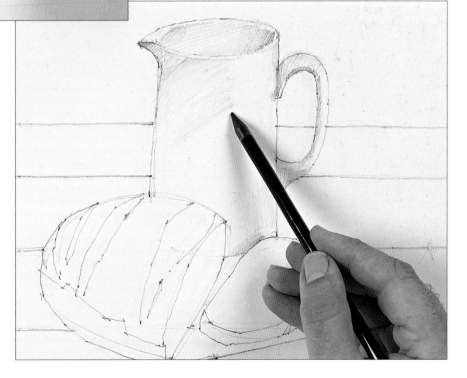

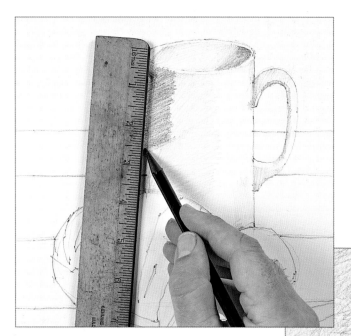

4 Consider the darker strip on the side of the jug that is furthest away from the light. Instead of working freehand, which requires you to draw carefully up to the edge of the jug, use a ruler to create a mask. Hold the ruler in place along the edge of the jug and scribble loosely and rapidly up to the ruler, to create a crisp edge.

5 Now establish the mid-tone background, making multi-directional, scribbled strokes with a relatively uniform pressure. Use the ruler to mask the edge of the jug where it abuts the background if you wish.

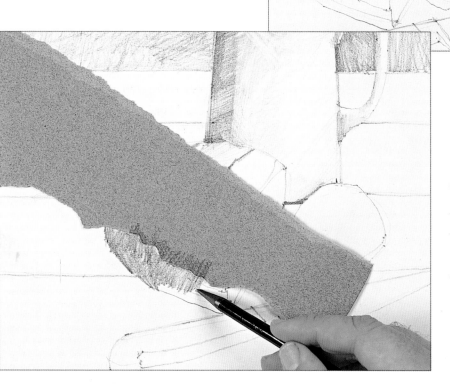

6 When it comes to drawing in the dark shadow on the side of the bread you can use a masking technique again. Give the bread a rough edge by using a torn sheet of paper as the mask.

7 To render the pitted surface of the bread and the texture within the slices, place an artist's canvas board beneath your paper and use the 2B graphite stick to scribble over the surface. The graphite will pick up the texture, leaving a wonderfully rich and interesting series of marks perfect for representing the surface of the bread.

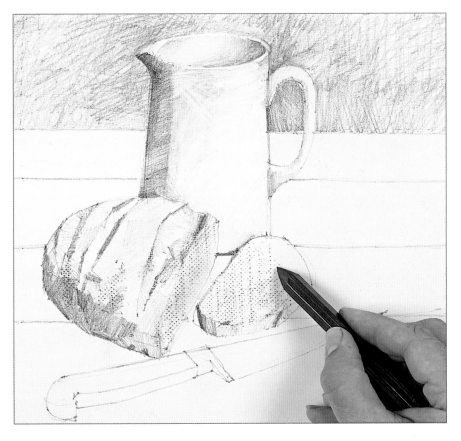

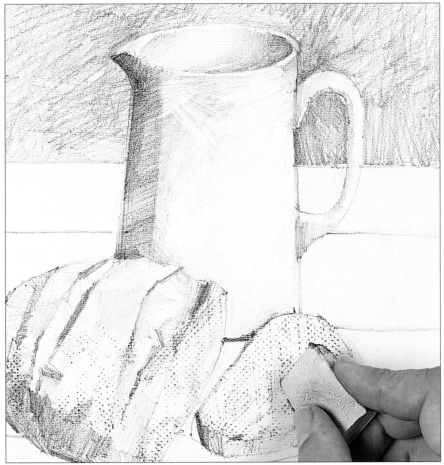

8 Remove the canvas board and complete the texture of the bread by working into the drawing using loose graphite marks and erasing techniques (see page 65).

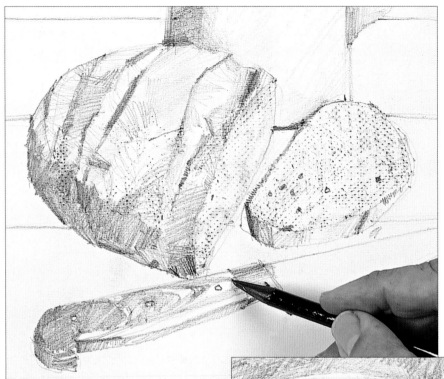

9 Now add tone to the handle of the knife, taking care to draw in the grain of the wooden handle so that it follows the contours of the wood.

10 Place the rough wooden board beneath your paper now, to draw the tabletop. Use the 3B graphite stick, rubbing in the direction of the grain, to transfer its image on to your drawing.

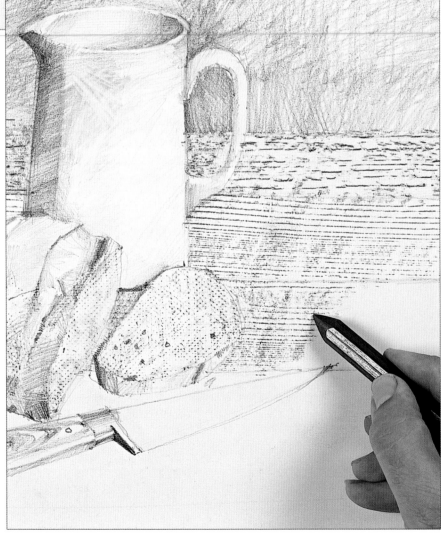

11 Define the individual strips of wood that make up the tabletop by applying lines of darker tone. Apply darker tone, also, to create the shadows beneath the objects.

12 The finished drawing demonstrates how the smooth finish of the porcelain jug, the pitted rough texture of the bread and the linear surface of the wood grain can be successfully achieved using a variety of advanced techniques.

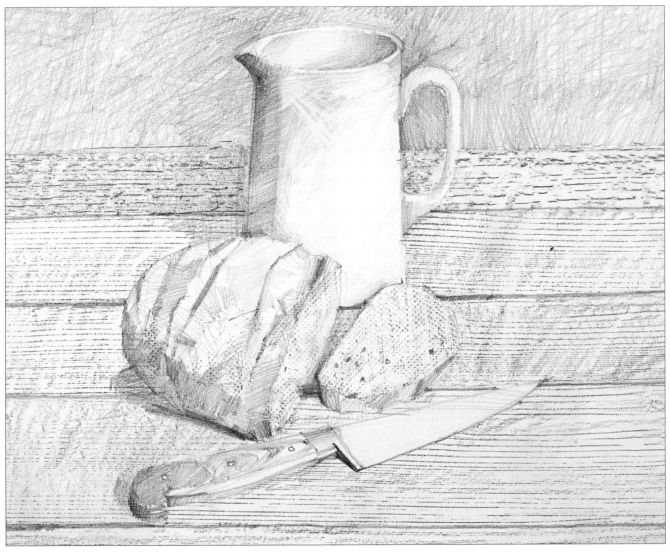

Step 9
composition

focus: arranging the elements

Materials

White cartridge paper, 300 gsm/140 lb

Medium charcoal pencil

Putty eraser

The composition of a drawing is the way in which you arrange the subject matter within the confines of the picture area. Good composition persuades a viewer to focus on those elements that you deem most important and to 'read', or travel through and around, the image in a specific way. All aspects of drawing discussed so far in this book – scale, perspective, tone, colour and texture – influence composition.

RULE OF THIRDS

A very simple system of arranging the space within a rectangle – the usual shape of a picture area – is known as the 'rule of thirds', which, once mastered, can be used instinctively. The basic principle here is to divide the space into thirds both horizontally and vertically. Placing important elements on or around the grid lines, or where they intersect, invariably results in a pleasing composition.

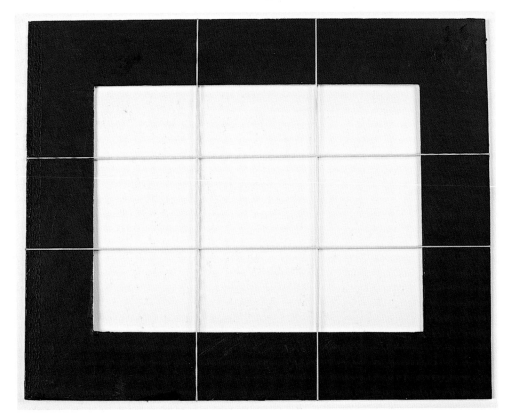

Using a viewing frame:
In order to look for possible compositions, you can make a simple viewing frame by cutting a rectangular aperture in a sheet of card and stretching four rubber bands across so that the aperture is divided equally into thirds both horizontally and vertically.

FORMAT AND CROPPING

The first thing to consider when making a drawing is its format, because this will have a direct influence on your composition. There are three main formats:

• Landscape: a rectangle with the longest side running horizontally.

• Portrait: a rectangle with the longest side running vertically.

• Square: while the proportion of the two rectangular formats can be altered, the square format always remains square, no matter how large or small.

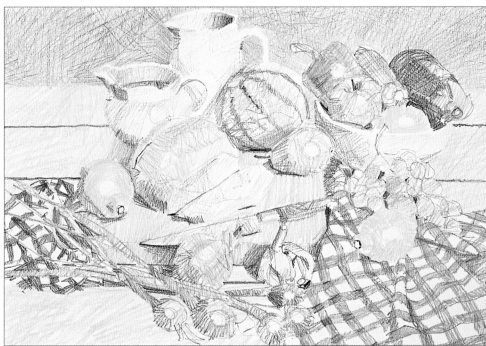

Horizontal format:

A horizontal rectangular format persuades the eye to view a drawing from side to side.

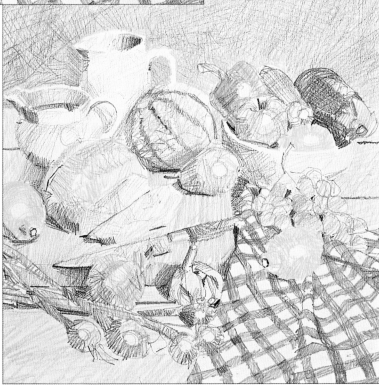

Vertical format:

A vertical rectangular format persuades the eye to travel up and down the drawing.

Square format: A square format persuades the eye to spiral around the image but ultimately it is drawn to the centre.

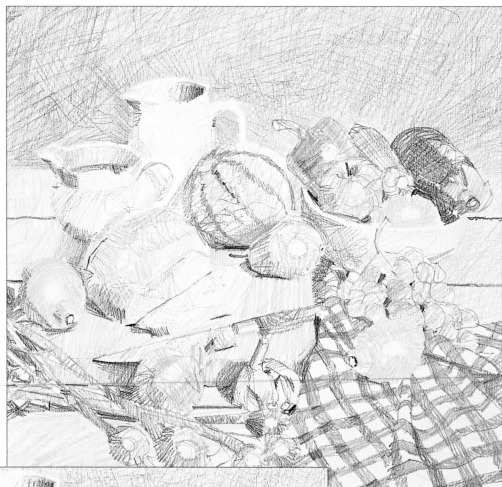

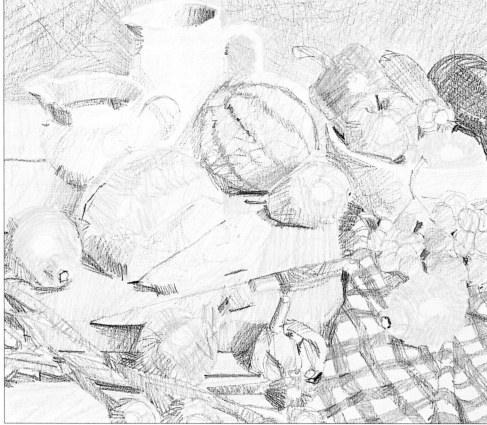

Tight crop: Cropping tight into a subject tightens the overall composition and introduces an almost abstract feel to the piece.

BALANCE

Balance is achieved by using what is referred to as 'point and counterpoint'. For example, a large object or mass might be balanced by a much smaller object or mass that is much brighter in colour; a complex arrangement of objects might be balanced by a simple but heavily textured area. There are various ways of introducing point and counterpoint: thick with thin; black with white; bright colour with texture; complex with simple, the possibilities are many.

ANGLE OF VIEW

A still-life arrangement can be seen from a full 360 degrees, which means that the possibilities are many when it comes to deciding on composition. Seen from above, and at a distance, the objects appear to be spread out with plenty of space around them. The objects can be seen more or less in their entirety and there is a distinct feeling of depth to the image. Seen from the side, however, the exact same arrangement appears tighter, with the objects creating interesting shapes as they appear one in front of the other. Such an image, although just as valid as the first, appears flatter and without any great sense of depth.

USING THUMBNAILS

In order to decide on the right composition for a drawing, an artist might prepare a series of small compositional sketches, known as thumbnails. These need only be large enough to give a quick impression of what the final composition will look like.

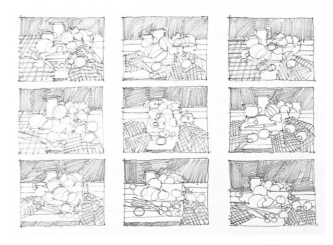

Explore the possibilities: Thumbnails help you to arrange the elements within the picture area and assess various compositional options.

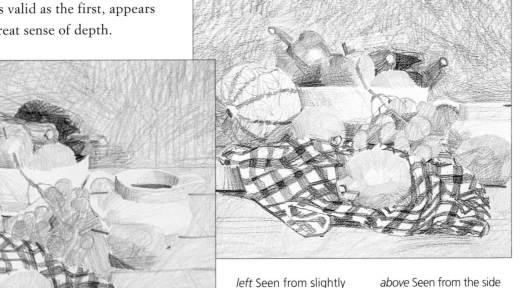

left Seen from slightly above this arrangement has depth.

above Seen from the side the arrangement appears to have less depth.

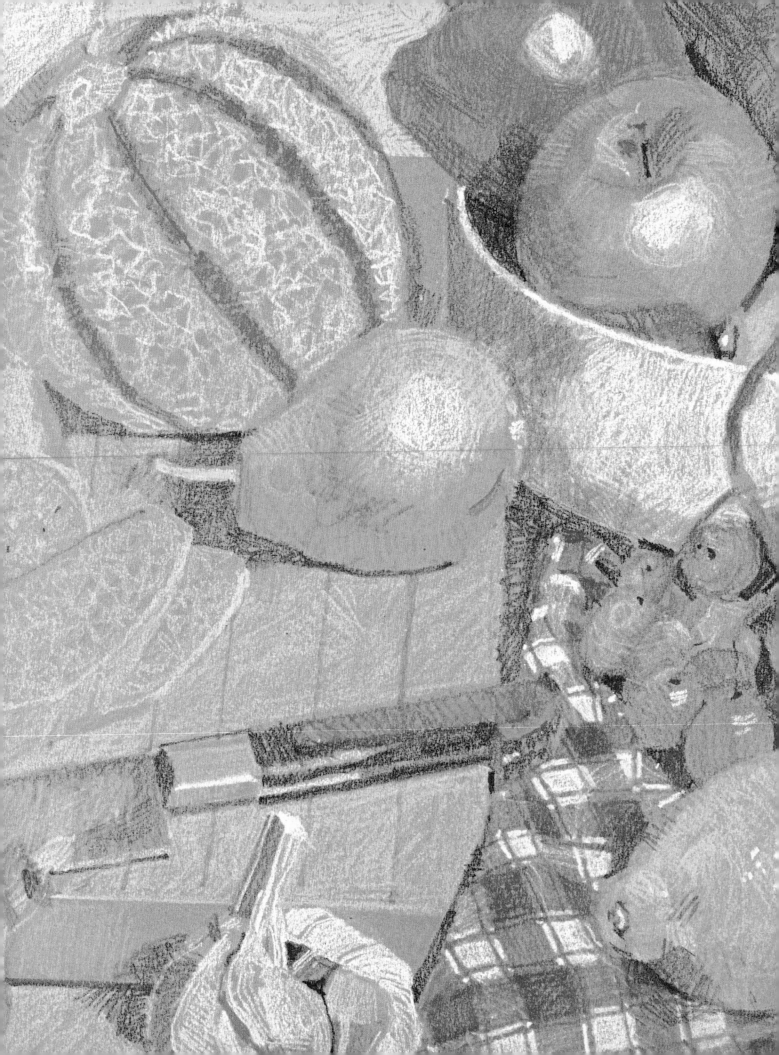

Step 10
bringing it all together

focus: still-life drawing

Materials

Beige pastel paper, 160 gsm/90 lb

Fixative

Sheet of scrap paper

Ruler

Pastel pencils:

- *White*
- *Mid grey*
- *Light grey*
- *Dark grey*
- *Cadmium red*
- *Crimson*
- *Cadmium orange*
- *Cadmium yellow*
- *Lemon yellow*
- *Naples yellow*
- *Olive*
- *Light green*
- *Mid green*
- *Lime green*
- *Indigo*
- *Violet*
- *Light violet*
- *Light blue*
- *Burnt sienna*
- *Burnt umber*
- *Yellow ochre*
- *Light ochre*
- *Terracotta*
- *Black*

The artist can manipulate a still life, arranging content, lighting, colours and composition to suit, and this makes it a perfect project from which to learn. Here, a range of typical objects give a variety of shapes, textures and colours to render using a wide variety of drawing techniques.

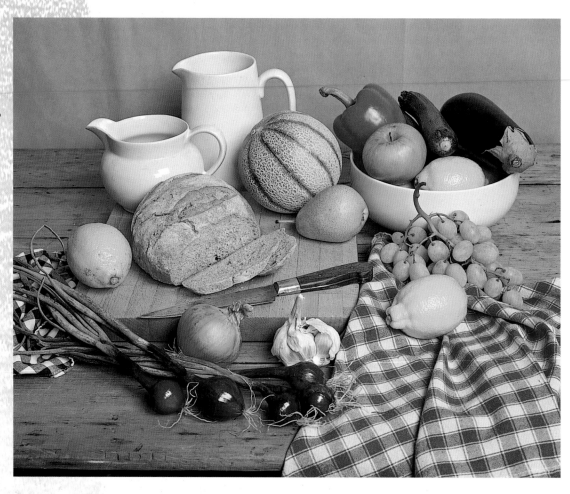

The order in which colour is added is not entirely arbitrary. In this case, the addition of colour begins in the top left-hand corner and progresses in a left-to-right, top-to-bottom direction. This is because the artist is right-handed and working in this direction enables him to always rest his hand on an area that has not been freshly drawn on.

Stage 1: proportion, shape and perspective

1 Use the white pastel pencil to sketch in the approximate shapes and positions of the main elements (see pages 20–25). Take a few measurements to assess the relative size of the objects and their positions in relation to one another. Use a light fluid line.

2 Use very simple shapes at this stage. The idea is to get the composition right, and this is the best time to make any alterations in position. Do not be too concerned about the white line showing up where it is not wanted. Lightly brushing over it will reduce its presence and subsequent pastel pencil work will obliterate any of the initial construction lines.

3 Once you are happy with the composition, you can develop the shape of the objects. In each case use a colour that loosely corresponds with that of the object. When drawing the white jugs, use perspective to achieve the correct shape of the ellipses and orientation of the jugs (see pages 28–33). As you work, mark loosely the extent and position of any major areas of tone together with any highlights.

4 Using the relevant coloured pencils, work over the whole image, redrawing and redefining the shape of each object. Use your initial sketch as a guide but do not slavishly follow the lines made previously. Relate each object to its neighbour, taking measurements if needed, as you go. Use contour lines to show the direction of surfaces and mark any major changes in light and shade (see pages 44–45).

5 Draw the cloth carefully, noting its position, shape and the direction of pattern (see pages 72–77). Draw all of the lines running in one direction before drawing any lines running in the other direction.

6 Stand back and take a look at your drawing. So far the work has been concerned with establishing the correct positions and shapes of the objects. There is already a feeling of depth, helped by the addition of a few contour lines and perspective. This line work will not interfere with any subsequent work and should disappear as you continue to build up the drawing. At this point you can give your drawing a light coat of fixative to prevent smudging.

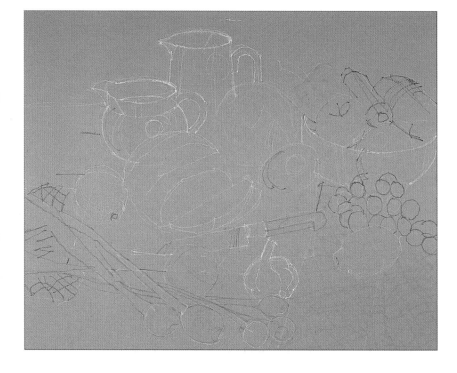

Stage 2: establishing colour and tone

7 The most important thing to remember as you add colour and tone is to avoid a 'filled in' look. Begin by adding white to the two ceramic jugs, and using a mid grey for those areas in shadow. Keep the pastel work 'open' and do not attempt to completely obliterate the background colour. Your colours will deepen as you apply more layers of pigment.

8 Progress to the fruit and vegetables in the white ceramic bowl. Use cadmium red, crimson and cadmium orange for the pepper itself and olive, light green and mid green to establish the colours on its stem. You can use the same colours for the courgette and apple. To achieve the glossy skin of the aubergine, use indigo, violet and light blue. Establish the colour of the lemon using cadmium yellow and lemon yellow. Scribble in the highlight using Naples yellow. You can also use Naples yellow for the highlights on the apple, while the highlight on the pepper should be white.

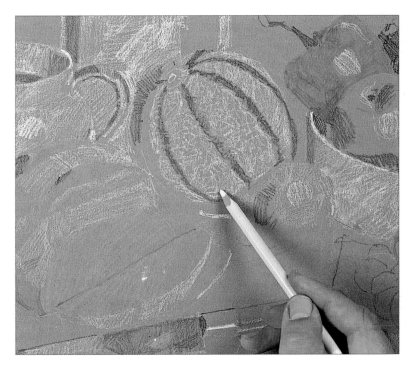

9 Establish the lemon next to the bread using the same colours you used for the lemon in the bowl. Now draw the loaf of bread, using burnt sienna and burnt umber for the side of the loaf in shadow, and yellow ochre and Naples yellow for the rest of the crust. Draw the 'white' of the bread using a combination of light grey and light blue. Draw the pear using lime green and mid green with white for the highlights. Use a dark grey for the blade of the knife and yellow ochre for the brass around its middle. Work on the linear pattern that curves around the melon using mid green, scribbling in Naples yellow to suggest the pattern and texture on its surface (see pages 64–69).

10 Pick out the linear pattern on the skin of the garlic using white and dark grey (see pages 36–41). Draw the foliage of the small onions using mid green and use crimson for the bulbs. Turn to the onion, using yellow ochre, burnt umber and cadmium orange. Use light violet for the shaded areas.

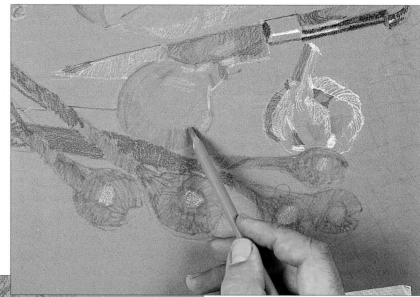

11 With a careful eye on their positions on the red checked cloth, draw the grapes, using light green, and the lemon using the same colours as in steps 8 and 9. Using cadmium red, carefully block in the linear pattern on the cloth.

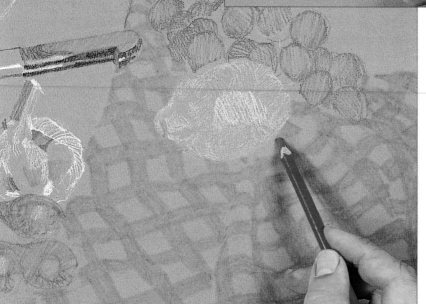

12 Start to draw the pattern on the cloth to the left of the composition, using black. Remember to look at the way that the pattern follows the folds of the cloth.

13 The colour of all of the major elements has now been established. Stand back from your drawing and notice how the colour of the paper ties the whole drawing together, working behind the colours to unify them and help create an overall colour harmony.

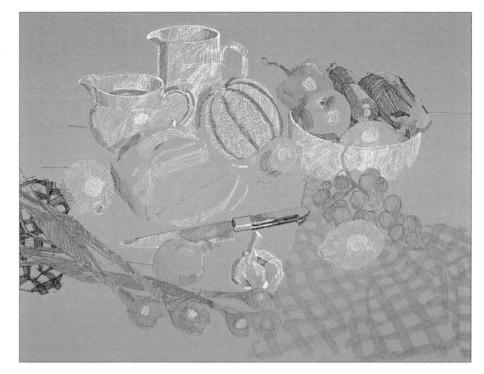

14 Establish the colour of the wall behind the still life. Using a light ochre, work across the area, drawing blocks of hatched and crosshatched lines to build up the colour. Notice how the still-life objects immediately appear to advance as the lighter wall colour is added around them.

15 Repeat the process, using the same colour, to establish the colour of the chopping board.

16 Use burnt sienna to draw the shadow cast by the onion, then continue with the light ochre pencil to work around the objects at the front of the tabletop.

17 Complete the background blocking by using the yellow ochre pencil to establish the colour of the tabletop at the rear of the setup. Stand back from your drawing. The objects now appear to stand firmly on the surface rather than floating in space. The feeling of depth is more pronounced, as the tabletop appears to advance towards the viewer. This in part is due to using the darker colour at the rear of the table and the lighter colour to the fore. Apply another light spray of fixative. This will deaden the lighter colours somewhat, but will allow more layers of colour to be applied without smudging.

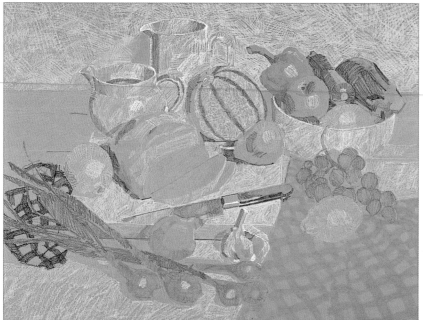

18 You can now rework the colours across the image. The fact that the spray fixative reduces or 'knocks back' the colours actually works to your advantage. It means that, in effect, the amount of colour you use is 'doubled' up. You can see this clearly as you begin to apply a second layer of colour. Here, the white being applied looks clearer and brighter than the white that had been drawn previously. The build-up of the pigment has a certain amount to do with this, but the process of fixing also helps.

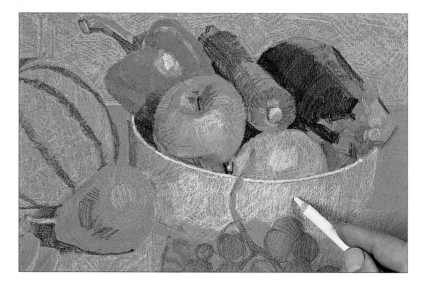

19 At times you may find that no single colour is quite right, as here, when it comes to the grapes. You need to mix the right colour carefully – with sharp pencils – by laying one over the other. Use light green, mid green and light blue, drawing linear strokes that follow the contours of each grape (see pages 22–25). Try your colour mixes on a sheet of scrap paper before committing yourself.

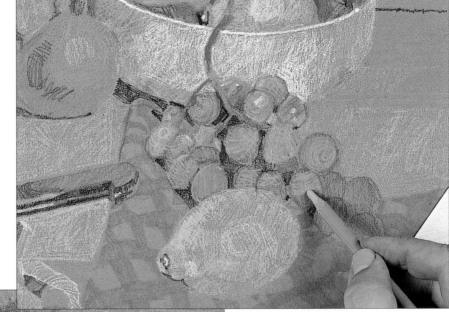

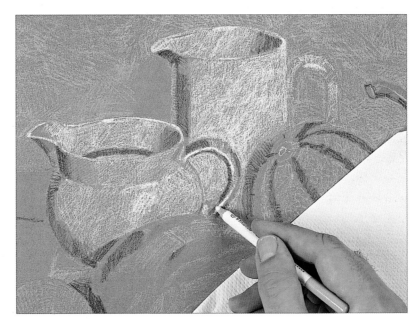

20 Using cadmium red, draw in the lines of the pattern that fall either side of the thicker stripes on the cloth. Where the pattern overlaps, deepen the colour by using crimson. Use white for the lighter squares.

21 Return to the two ceramic jugs. Use the white pastel pencil to re-establish the highlights and use the light blue, mid grey and yellow ochre to draw in the areas of reflected light and shadows. Although the image has been fixed you may still soften the focus or sharpness of the image by rubbing it with the side of your hand. Working with a sheet of paper towel beneath your hand should prevent this from happening.

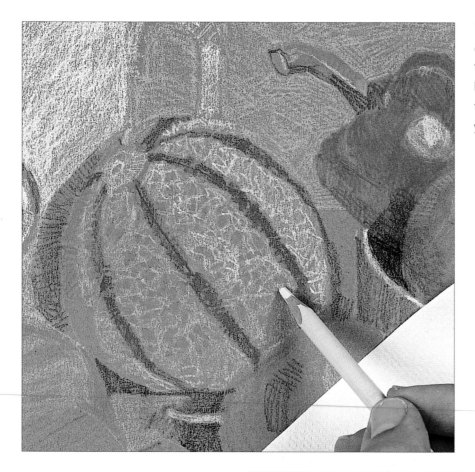

22 Use a combination of mid grey and mid green pencils for the light green that shows through the lighter pattern on the melon. Redraw the linear pattern as before using Naples yellow (see pages 64–69).

23 Use lime green on the topmost part of the pear and scribble a band of cadmium orange down the topmost edge to capture the shadow cast by the melon.

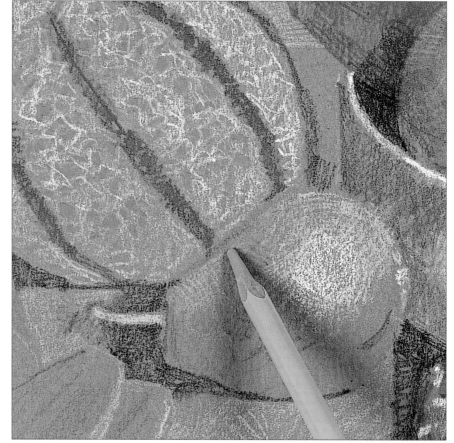

Stage 3: establishing texture and detail

24 Return to the crusty loaf of bread. Scribble crosshatched lines of burnt umber and light ochre that follow the uneven surface, and use terracotta and Naples yellow to render the dusting of flour. Colour the inside of the bread with yellow ochre, adding darker textural marks using the dark grey.

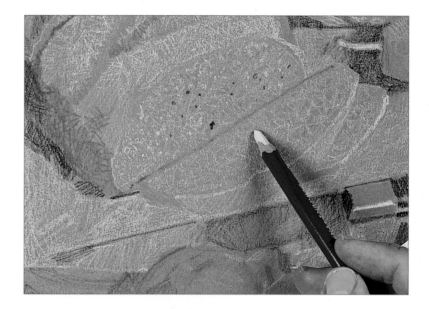

25 Deepen the colour of the lemon by the loaf by crosshatching layers of cadmium yellow, lemon yellow and a little light green. Use Naples yellow for the highlights and work carefully around the stalk area in black.

26 Capture the reflective quality of the knife blade by 'glazing' light blue over the dark grey applied in step 9.

27 Enrich the colour on the onion using more burnt umber, worked over indigo. Use the same mix of colours for the deep shadow cast by the onion on to the edge of the chopping board and the tabletop.

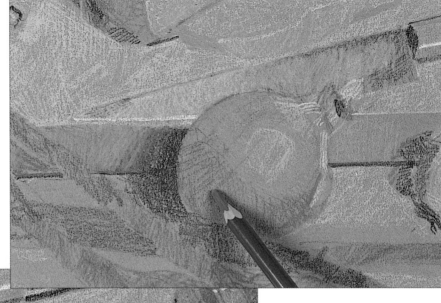

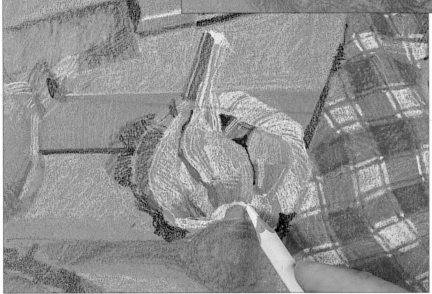

28 Capture the slight pink bloom on the bulbs of garlic using light strokes of crimson. Apply dark and mid grey where there are shadows and Naples yellow where there are highlights. Use indigo to define the dark interior and shadow beneath the garlic bulb.

29 Return to the black-checked napkin. Apply mid grey over the black to draw in the lighter grey squares and use white to define the lighter squares.

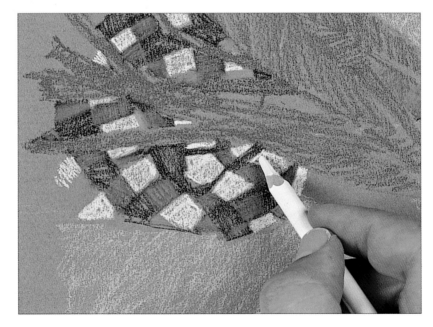

30 Redraw the stems of the small onions that are in shadow using dark green. Use lime green to 'glaze' over the mid green on the lighter coloured stems, and deepen the others using scribbled applications of light green.

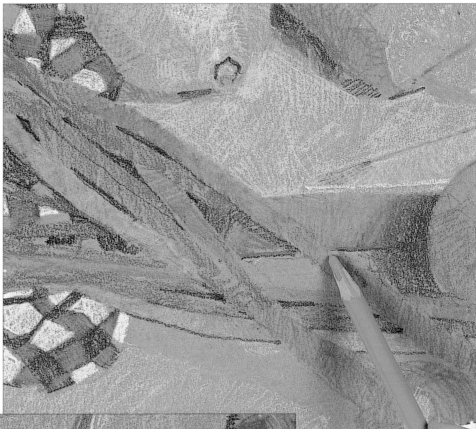

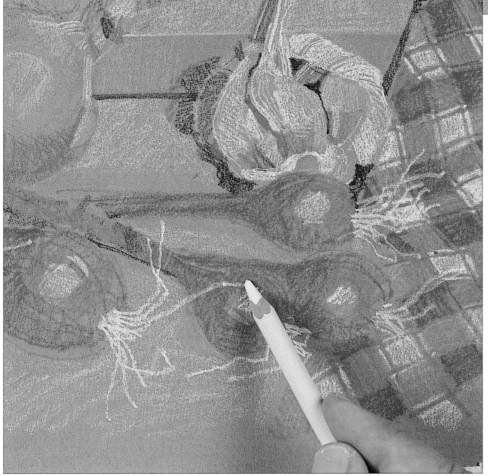

31 Give the small onion bulbs more form using crimson, indigo and cadmium red. Apply linear marks of Naples yellow to define the roots.

Stage 4: finishing touches

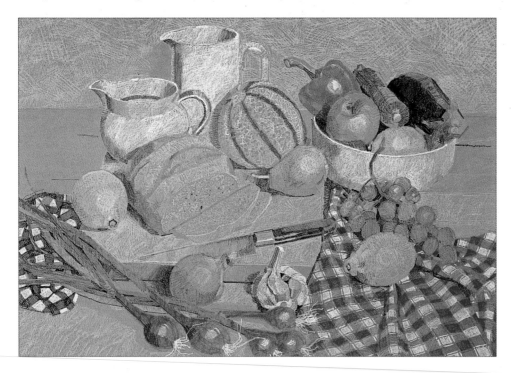

32 Step back and assess progress so far. While the colour and shape of the objects themselves appear satisfactory, the tabletop and background now look soft and appear to lack 'bite'. Now is the time to intensify and deepen the colour of both and add detail to the tabletop.

33 Create a crisp edge between the wall and the table by working yellow ochre up to a ruler, which should act as a mask. Leave the colour of the support showing through to represent the shadow on the wall cast by the jug: add a little dark grey to darken the area slightly.

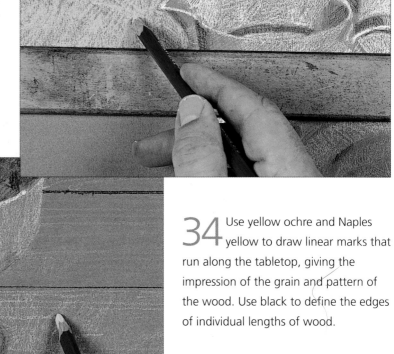

34 Use yellow ochre and Naples yellow to draw linear marks that run along the tabletop, giving the impression of the grain and pattern of the wood. Use black to define the edges of individual lengths of wood.

35 Use burnt sienna to draw the strips of wood that make up the chopping board. Pay particular attention to the angle at which the lines run, making sure that they match the perspective of the edges of the chopping block (see pages 28–33).

36 See how the pitted surface of each lemon shows up clearly where light reflects off its surface. Draw this in with the white pastel pencil, applying more pressure as you make the precise marks.

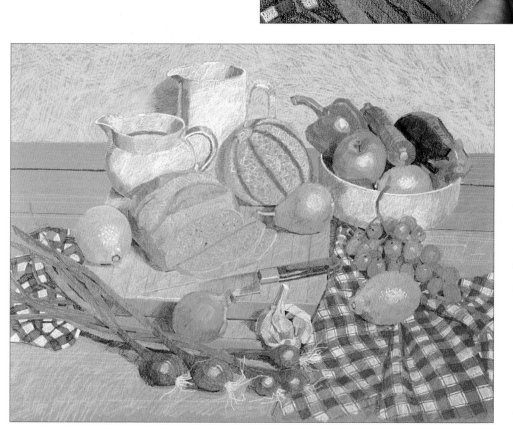

37 All of the techniques from the previous nine steps have been used to complete this project. You may be tempted to fix the finished drawing, but fixative does tend to reduce the intensity and brightness of the lighter colours. It is better to protect the work with a sheet of tissue or tracing paper and place it carefully in a drawer or portfolio until it is framed.

taking it a step further
sunflowers & country landscape

focus: sunflowers

Materials

Hot-pressed watercolour paper,
 300 gsm/140lb

2B graphite pencil

Dip pen

Fine steel nib

Medium steel nib

Bisque waterproof drawing ink

Reed pen

No 2 sable brush

Sheet of scrap paper

White gouache

Putty eraser

Cocktail stick

Water

A bunch of six sunflowers are arranged in a glass vase. The flower heads alone are the subject of this drawing, which serves to tighten up the composition, focusing attention on the flowers themselves rather than any of the surrounding elements. The subject on first glance is relatively simple. However, each of the flower heads are quite complex. The many petals with linear markings and the spiral of seeds at their centre make them a perfect subject for pen and ink.

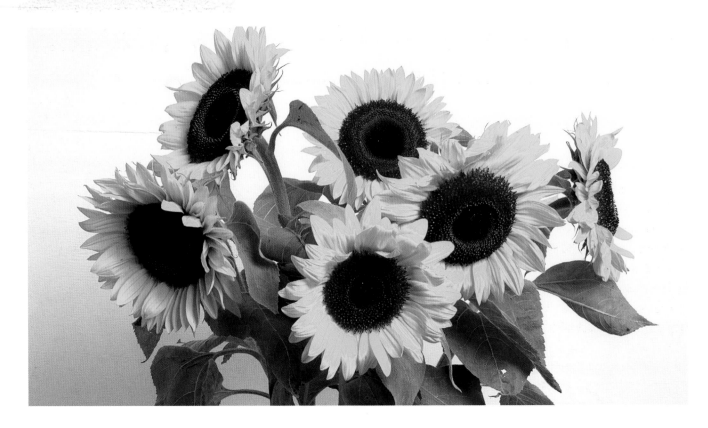

Stage 1: establishing the ink outline

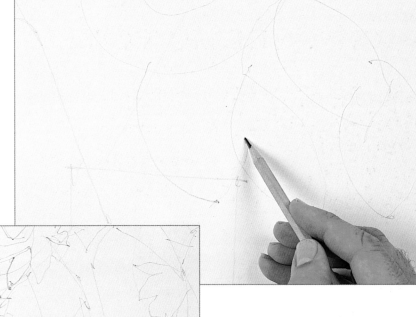

1 Begin the drawing by using the 2B pencil, very loosely, to sketch out the position and approximate orientation of the flowers and leaves (see pages 20–25). Use a light line that can be carefully erased later if necessary.

2 Once you have established the position and approximate orientation of the flowers, develop the drawing further by adding the petals and defining the leaf shapes. Again, work loosely and lightly, using the negative spaces and shapes around the main elements to help you draw the flower heads accurately (see pages 20–25).

3 The pencil drawing is meant to act as a guide for keeping your initial pen work on track. The directness of the material, and the apparent difficulty in making corrections when using pen and ink can be daunting. A pencil sketch goes a long way to alleviating these concerns, but should only be used as a guide and not slavishly followed.

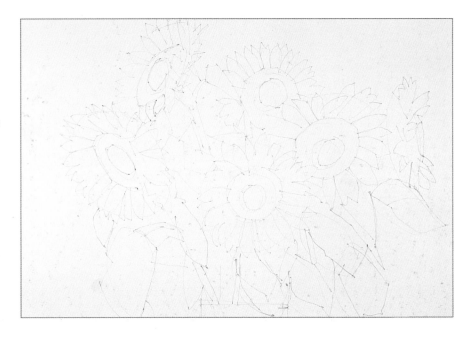

4 Dilute the bisque-coloured ink with clean water to approximately half strength. Begin the initial pen work with the dip pen and medium-sized nib. Use the pencil lines as a guide but redraw the flowers: do not simply follow the graphite lines.

5 Draw each flower in turn, progressing from the head to the leaves. Turn the pen between your fingers as you work, changing the pressure applied in order to vary the thickness of the line (see pages 36–41). As a general rule, use a thicker line in places that appear to be in shadow or dark in colour.

6 Pay careful attention when drawing the individual flower petals: notice how each one is different in shape. Draw in a few of the lines that can be seen on each petal's surface.

7 Take care to draw the petals so that each faces the right direction. This is especially important for the flower head to the extreme right, which is seen from an angle. Notice how you can see the front of some petals, but the rear of others.

8 Once you have established all of the main elements in ink, stand back from your drawing to view it as a whole.

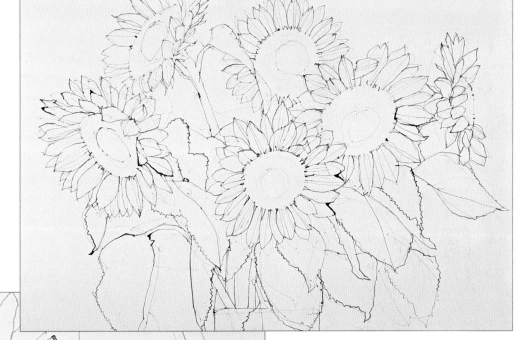

9 You can erase pencil lines at this stage, although they will tend to disappear beneath subsequent pen work anyway. If you do decide to erase them, make sure that the ink drawing is completely dry or you may smudge the lines. Ink can take a surprisingly long time to dry thoroughly, so it may be best to leave the drawing overnight. Alternatively use a hairdryer to speed up the process.

Stage 2: drawing the seed heads

10 Working on one flower at a time draw the seed heads, using the reed pen to make a series of blob-type marks around the outer edge. Allow the blobs to run together in places.

11 Use the dip pen with a medium nib as you complete the seed head, making a series of small, circular marks. Work towards the centre of the flower.

12 Now use the reed pen again to make a number of lines that radiate out from the centre of the seed head.

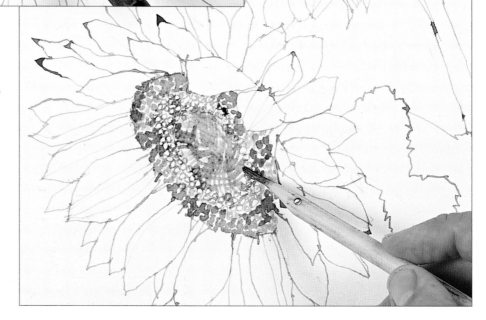

13 Gradually work across your drawing, moving from one flower to the next in the same way. Each flower tends to have a slightly different pattern of seeds at its centre, so avoid applying the ink in exactly the same way to each one.

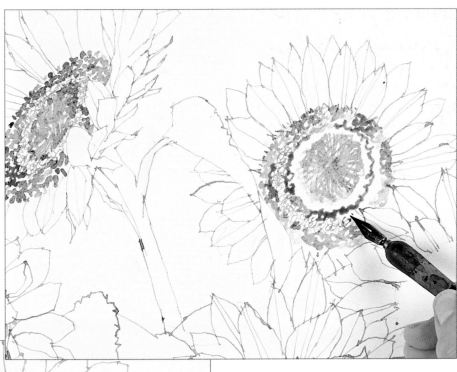

14 You can use a certain degree of inventiveness as you work. Here, the round end of a cocktail stick proves ideal for making the dark circular marks at the flower's centre.

15 You can also vary the textural marks across the petals by printing onto the drawing using a brush or finger dipped in ink. Make a few prints on a sheet of scrap paper before committing yourself.

16 You can use the cocktail stick again to render the darker pattern that runs around each seed head. Let the marks run into one another in places. You can build up this type of mark gradually, allowing one layer to dry before applying another.

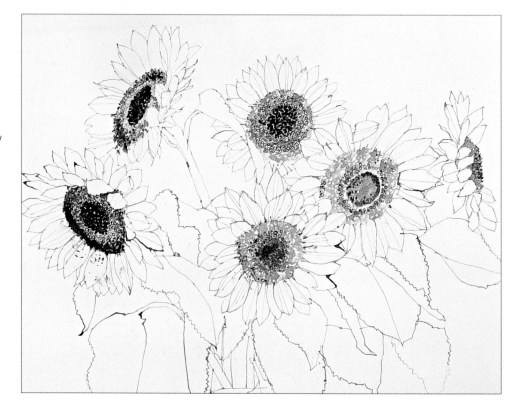

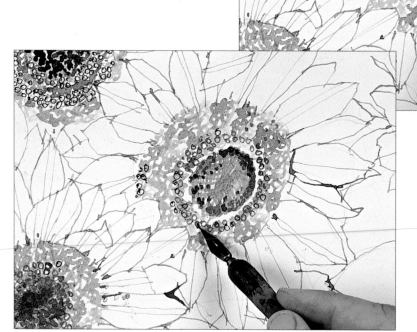

17 Once the ink is dry you can work over it using the dip pen with a medium nib, picking out areas for emphasis. (If you use the dip pen on a wet surface you will find that the pointed nib digs into and pulls at the wet paper, preventing a clean line from being made.)

18 When you have finished drawing the seeds at the centre of each flower, stand back to observe your work. The seed heads may look quite overpowering next to the delicate line work of the petals and leaves, but this will change as you progress the work and develop the rest of the drawing.

Stage 3: working on the petals

19 Use the dip pen with the fine nib and work carefully over the flower petals, drawing in the linear pattern that covers their surfaces (see pages 36–41).

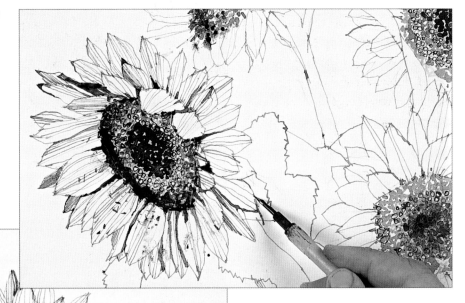

20 You can make some areas darker than others by allowing large amounts of ink to puddle on the surface of your paper, which you achieve simply by applying more pressure to the dip pen when making the mark. Use these marks around the edge of the seed head, at the point where the petals join the flower's centre.

21 Draw additional dark lines running from the centre of the flower and up the edges of some petals to suggest the shadow cast where one petal lies across another. Darker lines are made by applying pressure to splay the nib of the pen.

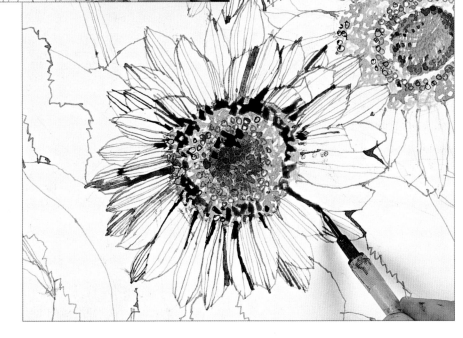

22 When it comes to completing the flower to the extreme right, darken the area between the petals seen from the front and those seen from the back, and place a few marks along the edge of the flower's centre, where it meets the petals.

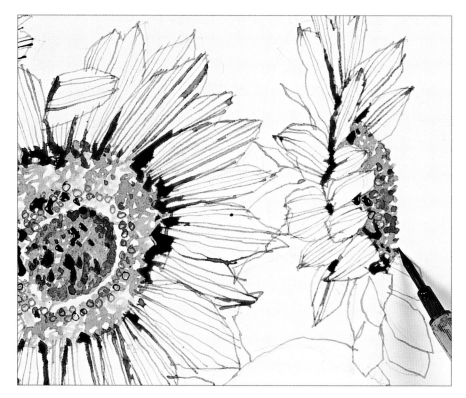

23 Stand back from your drawing. With all of the flower heads complete, you can see that the petals now look more integrated and clearly look firmly attached to the seed head of each flower.

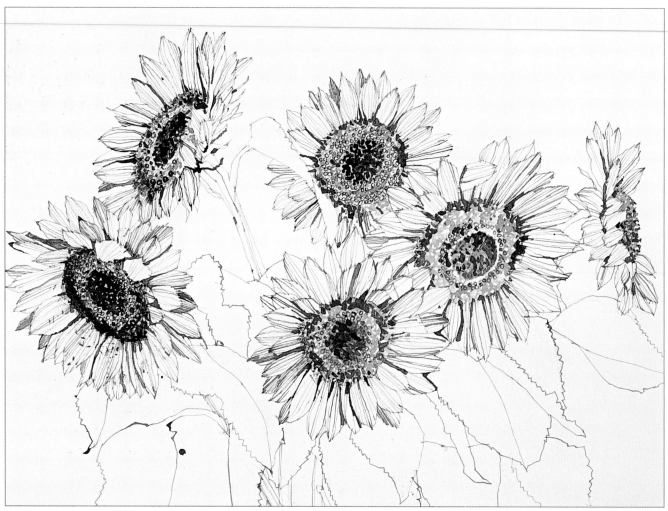

Stage 4: completing the stems and leaves

24 Use hatched and crosshatched lines to render the colours and tones of the leaves and stems accurately. Dilute the ink further to prevent this work from dominating your drawing, and use the medium nib.

25 Loosely scribble lines on the petals. This helps to make them appear more 'solid'. It also integrates the flowers more fully with the foliage. Do not be afraid to turn the drawing as you work if it makes varying the direction of the line easier.

26 Use loosely crosshatched lines to add tone to the leaves. Represent the paler leaf veins simply by leaving the paper white. Remember, when building tone using hatching techniques, it is always easier to add more marks to darken tones than it is to remove marks to lighten them.

27 Do not be put off if the thinned ink puddles as you work, or if crosshatched marks run together in places: they only serve to add interest, as long as they do not detract from the drawing or look impossibly out of place.

28 Stand back to observe your drawing once all of the leaves and stems are complete. It will resemble your subject more closely now that tone has been added. However, it may still lack depth, and this will be resolved as you complete the drawing. Allow it to dry well at this stage.

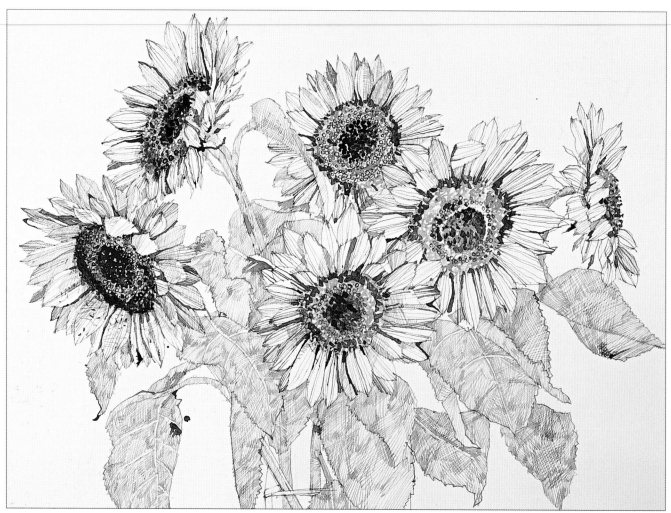

Stage 5: finishing touches

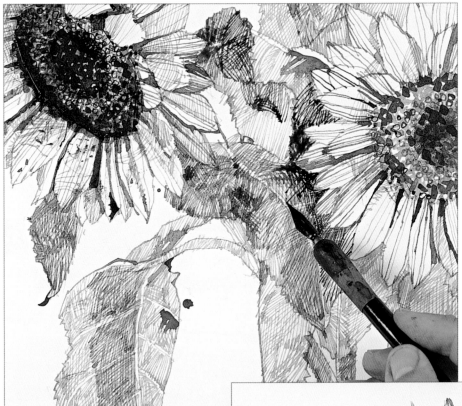

29 Darken the diluted ink by adding neat ink or use the ink at full strength if you wish. Still using the medium nib, begin to seek out those areas between and on the leaves that are darker in tone and build up the depth of that tone with more hatched and crosshatched pen work.

30 As you work across the drawing, draw an extra layer of marks on to the seed heads using the darker, denser ink.

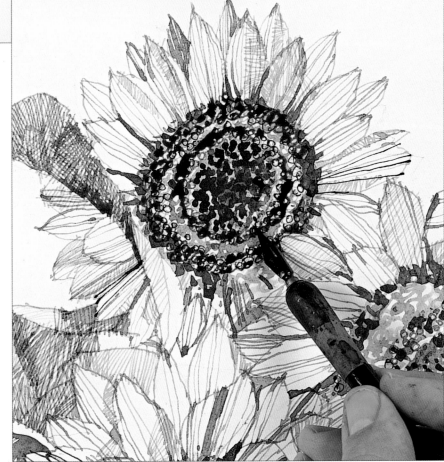

31 Clearly define the shadows cast on the leaf surfaces. This will help to capture the form and fall of each leaf, with leaves clearly positioned either in front or behind one another. If you do not do this the leaves will tend to appear as one flat mass.

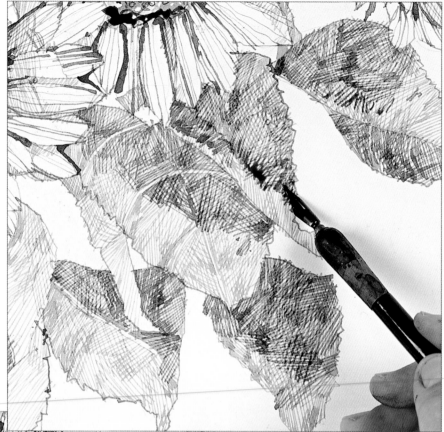

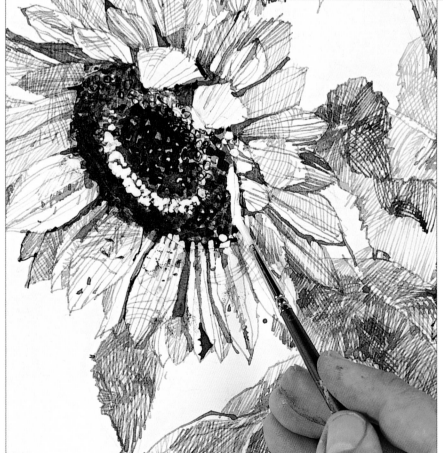

32 Use the sable brush with white gouache to break up some of the denser areas of ink and to redraw and bring out some of the finer details. You can see here that detail is added to the dark seed head to the left of the drawing. If the white gouache appears too bright, allow it to dry and use your finger to dab a little dilute ink on to the area in question. Do not rub the ink on: this will simply smudge the gouache. Once the gouache is completely dry, you can also draw ink on using the pen.

33 Apply gouache to some of the petals in the same way, cutting through the linear hatched marks. Any unwanted areas of ink can be painted over in this way, but be sparing. Otherwise you may compromise the freshness and spontaneity of the pen and ink work.

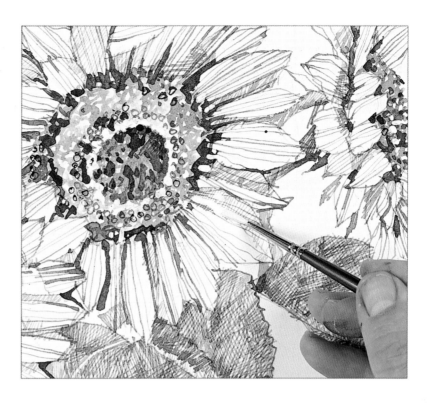

34 In drawing the sunflowers you will have used a number of techniques from the previous nine steps: including composition, measuring, line, textural and tonal techniques, to create the illusion of light and shade and give the flowers form.

focus: country landscape

Materials

Mid-grey pastel paper, 160 gsm/90 lb

Medium-soft charcoal pencil

Fixative

Hard charcoal pencil (optional)

Stick charcoal

White pastel pencil

This is a typical country view. Oak trees frame the view across the fields and a fence pulls the viewer into the distance. A gate invites entry and the whole is bathed in late summer sunshine, which casts dappled shade beneath the two trees. This exercise is drawn on tinted paper, which means that you will use charcoal to establish all of the tone that is darker than the mid tone of the paper, and a white pastel pencil to develop all of the tone that is lighter than the mid tone of the paper.

Stage 1: establishing the initial line work

1 Establish the composition and position and general shape of your subject using simple line work and the medium-soft charcoal pencil (see pages 20–25).

2 Draw the tree foliage very simply at this stage, with just the slightest indication of the position and direction of any branches. Use light lines to mark the positions of the receding fence, the gateway and the worn pathway that runs between the two trees.

3 Use the same charcoal pencil to mark the positions of the major clumps of foliage, using a nervous jagged line that frequently changes direction as it describes the shapes made by the leaves (see page 37).

4 Repeat the process, continuing to use a jagged line, around the edge of the tree canopy.

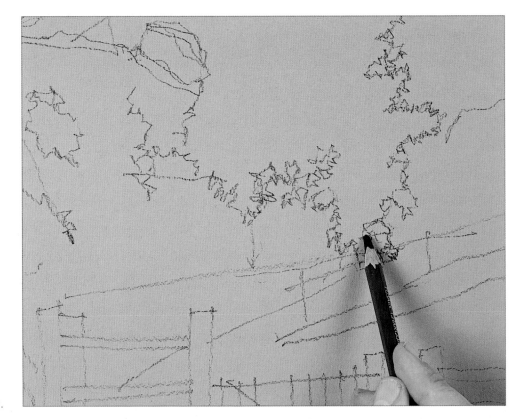

5 Draw the line of trees and shrubbery in the distance, and the shaded area beneath the trees. Make scribbled strokes to define the areas of grass, using the marks to suggest the direction of growth.

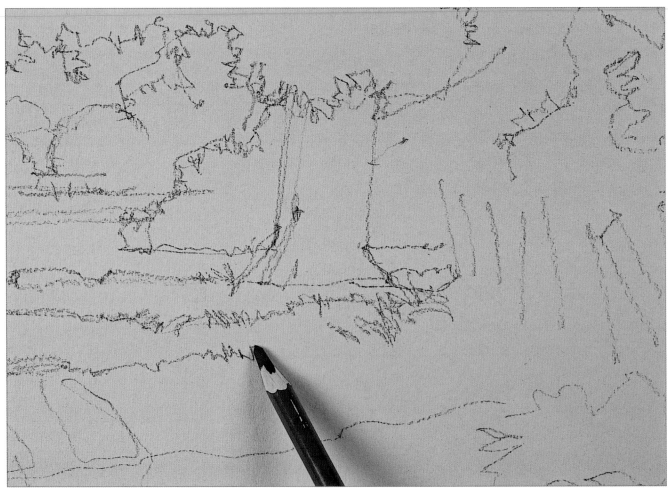

6 Now turn to the fence, an important compositional element, as it serves to pull the viewer into the picture. Although the fence is old and broken it will still conform loosely to the basic rules of perspective, so use these to make sure you draw it correctly (see pages 28–33).

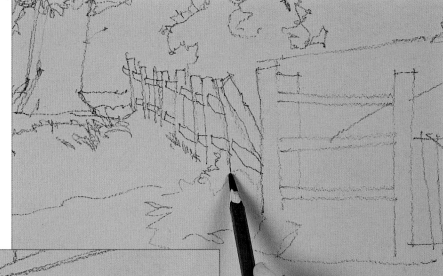

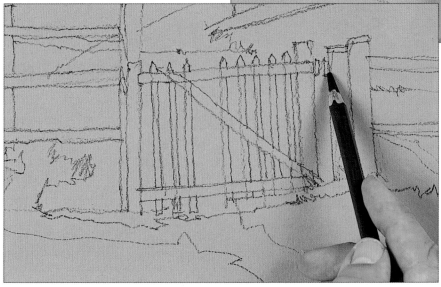

7 Take time to consider detail: for example, notice how some of the uprights in the gate are missing and how it is attached to the fence by old rusty hinges.

8 Stand back from your work. Your drawing now begins to resemble its subject and, owing to the row of fencing, already has a distinct feeling of depth. Once you are happy with the work at this stage, give it a light spray of fixative to prevent smudging.

Stage 2: building up detail

9 Still using the medium-soft charcoal pencil, draw in the tree line that runs across the image in the distance, applying a loose hatching and scribbling technique to give tone to each tree and shrub. Keep the tone relatively light by applying minimum pressure as you make your marks (see page 45). If you have difficulty applying a light tone using a medium-charcoal pencil switch to a harder one.

10 Work towards the front of the image. Draw in the band of rough grass across the far field, followed by the lighter patch of shadow between the two trees. Then, using a controlled scribbling technique, suggest the grass that is in shadow, and therefore darker in tone, which runs across the centre of the image.

11 Follow your creative instinct to improve the composition of your drawing by making more of areas with little interest. See here, how the artist exaggerates the plants scattered in the foreground. This helps to add interest without drawing the full attention of the viewer.

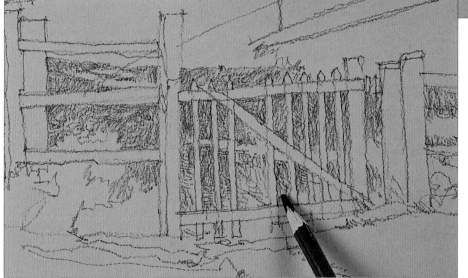

12 Draw the shaded area cast by the trees that can be seen between the bars of the gate. This will immediately throw the gate forward into sharp relief.

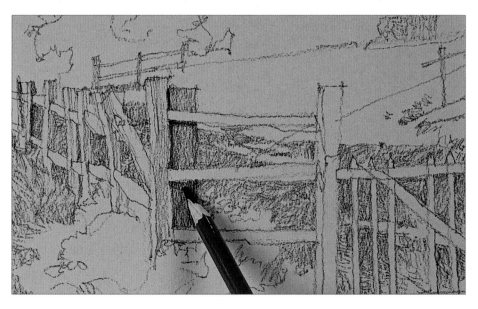

13 Draw in the dark tone on the fence uprights and the weathered grain lines on the side of each post using firm pressure. Drawing detail like this is much easier if you keep the pencil sharp.

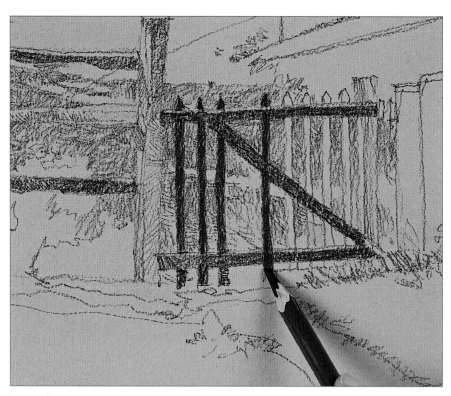

14 The wood of the gate is much darker, and you can draw this by using heavy strokes of the pencil.

15 Stand back from your work. Your drawing should look more interesting now, with plenty of variety in the pencil marks to represent the different surfaces and materials. Give the image a coat of fixative to preserve the work done so far.

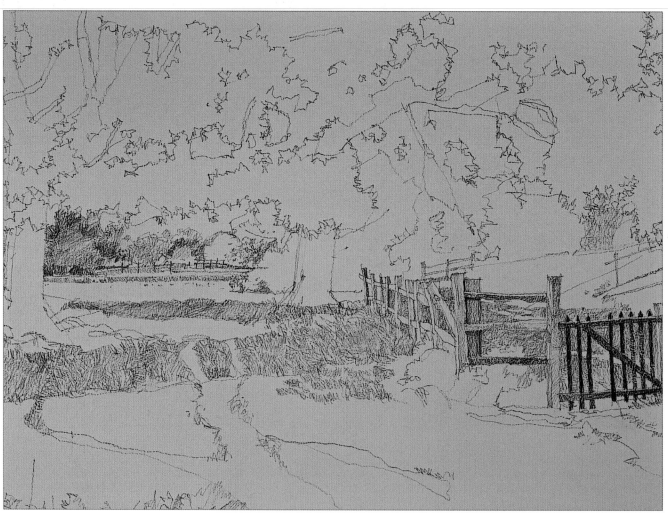

Stage 3: working on the darker tones

16 Use stick charcoal to create the darker tones: it is softer than the charcoal pencil and gives a denser, darker mark. Work across the image from left to right if you are right-handed and vice versa. This will prevent your hand from rubbing freshly applied charcoal as you work. Apply dense tone to the tree trunk and work the darker areas in the foliage and tree canopy.

17 Use the broad end of the stick charcoal to scribble loosely the shadows beneath the tree to the left of the composition, which are cast across the worn path.

18 Repeat the process on the tree to the right of the composition, working up into the canopy.

19 Use precise strokes when drawing the leaves, turning the charcoal between the fingers all of the time to keep a sharp edge on the stick.

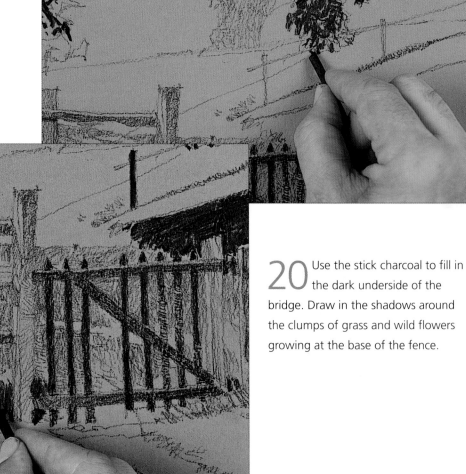

20 Use the stick charcoal to fill in the dark underside of the bridge. Draw in the shadows around the clumps of grass and wild flowers growing at the base of the fence.

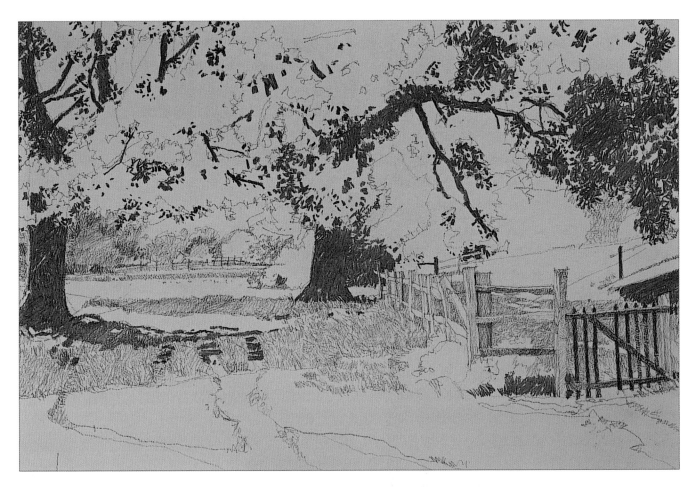

21 Stand back from your work. Notice how the feeling of sunlight is now apparent, as the darker tones increase the contrast of the drawing. You can spray a light layer of fixative over your work at this point.

22 Return to the medium-soft charcoal pencil and begin to lay in the tones that can be seen in the rest of the foliage. Use a loose, open scribble that not only makes the tone but also 'draws' or describes the shape of this mid-toned foliage.

23 Build up the foliage, increasing the density so that the trees appear more 'solid' and sit firmly towards the front of your drawing, framing the view beyond.

24 Develop the tone of the shrubbery and bushes in the middle distance using a light pressure. These bushes need to appear behind, and separate from, the large trees in front.

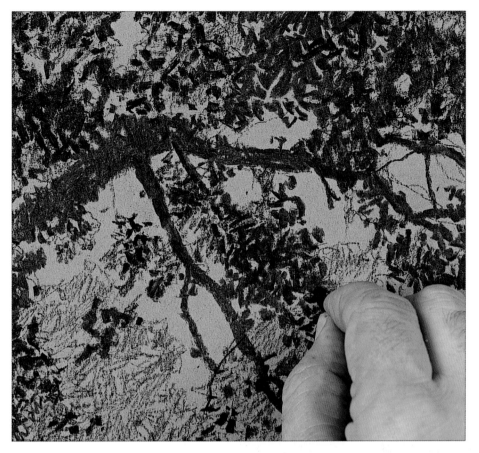

25 Return to the main trees and darken the foliage using the stick charcoal. Use short individual strokes instead of trying to cover the area quickly with a single layer of tone. It will take longer but the effect will resemble the countless leaves rather than one solid mass.

26 By this time, you should have completed all of the dark charcoal, with all of the tone that is darker than the mid tone of the paper firmly in place. You can fix the drawing. The image will look almost finished but slightly flat and lacking in contrast. The next few steps will change that dramatically.

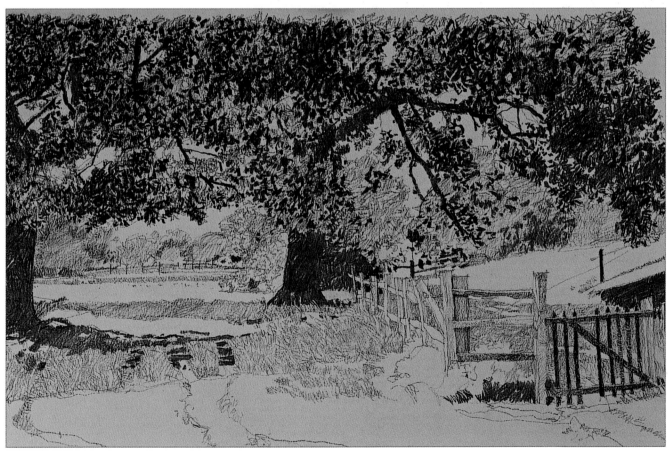

Stage 4: working on the lighter tones

27 Take the white pastel pencil and begin by drawing in the light areas of sky that can be seen through the gaps between the leaves and branches of the trees. These shapes are negative spaces and they are important as they inform the shape of the darker, positive, spaces (see page 21). Keep a reasonably sharp point on the pencil by turning it between the fingers frequently as you work.

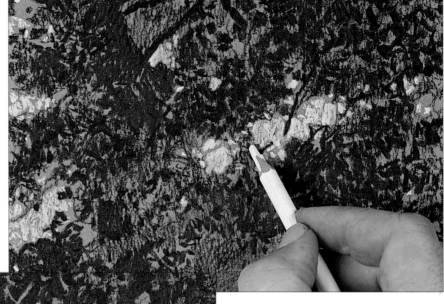

28 Gradually work across the image, seeking out the lighter shapes. They do not have to be followed slavishly: you can use a certain degree of creativity. The important thing is that they look convincing.

29 Continue the process around the edge of the tree, carefully cutting into and between the darker leaf shapes. Apply white pastel pencil to the rest of the sky area using multi-directional strokes.

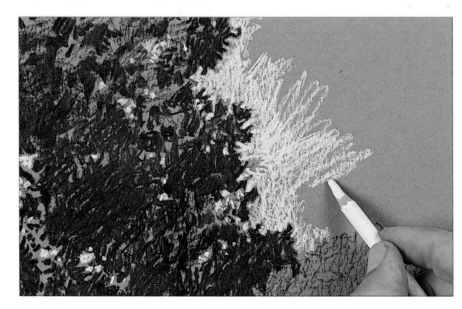

30 Work across the distant field using a series of light, upright strokes to suggest the long grass. Try not to create horizontal lines or blocks of grass, but keep the appearance more random.

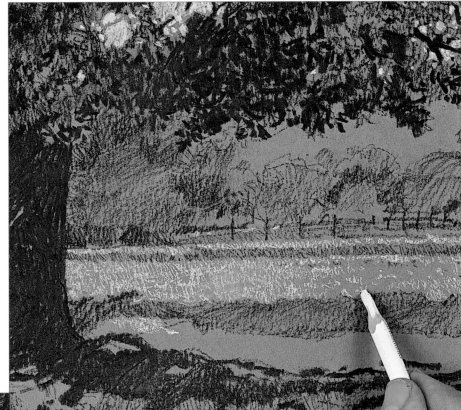

31 Continue the process on the bank leading up to the bridge that stretches over the river and out of the picture to the right.

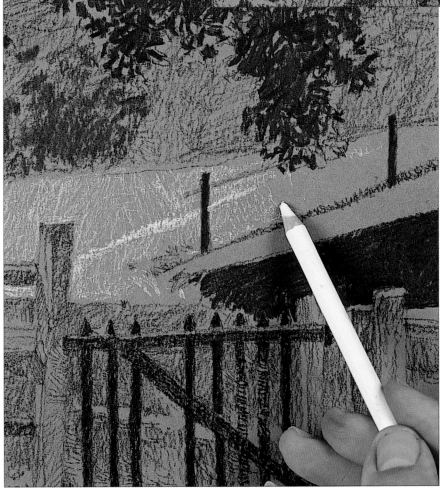

32 Use light, diagonal strokes to render the flatter tone of the compacted earth on the worn pathway. It should have a completely different appearance to the grass in the field.

33 Make precise marks using a firm pressure to capture the sunlight hitting the fence posts and the top of the gate.

34 Use light, diagonal strokes to render the tone of the earth pathway in the near foreground.

35 Work in the same way on the earth path running from the gate and add a few hard scribbled marks to hint at the overgrown grass on the river bank to the far right.

36 Drawing this landscape relies on good compositional and measuring techniques, as well as linear and aerial perspective to create a sense of depth. Textural and tonal techniques represent the different elements and the quality of light falling on them. You can fix the finished image to secure the pigment firmly to the paper. It will also help to retain the clarity and focus of the drawing.

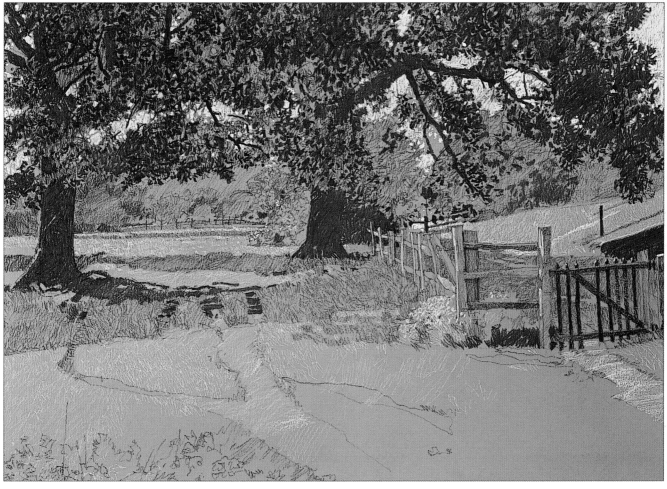

index

a

abstract patterns 73

advanced techniques 78–87

 jug, bread and knife project 80–7

aerial perspective 29

analogous harmony 55

angle of view 93

apple, lemon and pepper project 54–61

artist's pencils 14

aubergine, pear and lemon project
 44–51

b

balance, composition 93

bamboo pens 15

black 54

blending stumps 16

bread, drawing 80–7

Bristol paper 11

c

carré sticks 13

cartridge paper 11

chalks 13

charcoal 13

checked cloth project 72–7

circles 21

cloth 72–7

clutch pencils 12

cold-pressed paper (not) 11

colour 52–6

 apple, lemon and pepper project 54–61

 definition 54

 establishing 99–104

 practical considerations 57

 terminology 55

 using 56

colour temperature 55

colour value 55

colour wheel 55

coloured papers 11

coloured pencils 15

complementary colours 55

complementary harmony 55

composition 88–93

 angle of view 93

 balance 93

 cropping 91, 92

 format 91

 landscape format 91

 portrait format 91

 rule of thirds 90

 square format 91, 92

 using thumbnails 93

 viewing frames 90

compressed charcoal 13

cones 21

cotton wool buds 16

country landscape project 126–41

courgettes, drawing 64–9

craft knives 17

cropping 91, 92

cubes 21

 perspective 28–9

d

darker tones 133–7

depth, creating 29

detail, establishing 105–9, 130–2

dip pens 15

distorted patterns 73

drawing surfaces 65

e

ellipses, perspective 29

erasers 16

 creating textures 65

eye levels, perspective 31

f

fabrics 72–7

fixatives 17

flower projects 112–25

fluid lines 37

format 91

forms, simple 21

frames, viewing 90

frottage 81

g

garlic, drawing 36–41

grapes project 20–5

graphite 12

 blocks 12

 powder 12

h

harmony, colour 55

horizontal formats 91

hot-pressed paper 11

hue 55

i

ink 15

 establishing outlines 113–15

 using 39

j

jug, bread and knife project 80–7

jug and board project 28–33

k

knives 17

 drawing 80–7

l

laid papers 11

landscape format 91

landscape projects 126–41

layers, working in 65

leads 12

leaves, drawing 121–2

lemons, drawing 44–51, 58–61

light spectrum 54

lighter tones 138–41

line 34–41

onions and garlic project 36–41
 quality 37
 testing 36
 variation 37
 varying width 37
linear perspective 28–33

m
mapping out drawings 36
masking 80
materials 10–17
 artist's pencils 14
 blending stumps 16
 chalks 13
 charcoal 13
 coloured pencils 15
 drawing surfaces 11
 erasers 16
 fixative 17
 graphite 12
 pastel pencils 14
 pen and ink 15
 pencils 14–15
 sharpeners 17
measuring 20
melons, drawing 64–9
monochromatic harmony 55
multiple point perspective 29

n
negative shapes 21
nib holders 15
nibs 15
not paper 11

o
onions and garlic project 36–41
outlines, establishing 113–15, 127–30

p
papers 10, 11
 colour 57

pastel pencils 14
pattern 70–7
 checked cloth project 72–7
pears, drawing 44–51
pen and ink 15
 testing marks 36
pencil sharpeners 17
pencils 12
 artist's 14
 coloured 15
 pastel 14
pens
 dip 15
 nibs 15
pepper, courgette and melon project
 64–9
peppers, drawing 58–61, 64–9
perspective 26–33, 97–8
 aerial 29
 basic rules 28
 jug and board project 28–33
 linear 28–33
petals, drawing 119–20
plastic erasers 16
portrait format 91
primary colours 55
proportion 18–25, 97–8
putty erasers 16

q
quill pens 15

r
reed pens 15
 using 40
rough papers 11
rubbers (erasers) 16
 creating textures 65
rubbings 81
rule of thirds 90

s
sandpaper blocks 17
saturation 55
scalpels 17
scratching techniques 81
secondary colours 55
seed heads, drawing 116–18
sgraffito 81
shadows 60
shapes 18–25, 97–8
 grapes project 20–5
 linear perspective 28
 negative 21
 subjects and 21
sharpeners 17
single point perspective 28
size 20
smooth papers 11
spectrum 54
spheres 21
square format 91, 92
squares 21
stems, drawing 121–2
stick charcoal 13
still life project 96–109
stumps 16
sunflower project 112–25
surface pattern 72–7
surfaces 11

t
temperature, colour 55
tertiary colours 55
texture 62–9
 drawing surfaces 65
 erasing 65
 establishing 105–9
 frottage 81
 papers 11
 pepper, courgette and melon project
 64–9
 techniques 64

working in layers 65

thirds, rule of 90

thumbnails 93

tinted papers 11

tonal values 44

tone 42–51

 aubergine, pear and lemon project
 44–51

 creating 45

 darker 133–7

establishing 99–104

lighter 138–41

masking 80

quality 44

scale 44

transition 45

torchons 16

tortillons 16

triangles 21

two-point perspective 29

v

value, colour 55

vertical formats 91

viewing frames 90

vine charcoal 13

w

white 54

woven papers 11

acknowledgements

Executive Editor Katy Denny
Editor Charlotte Wilson
Executive Art Director Leigh Jones
Designer Miranda Harvey
Production Controller Nosheen Shan
Photography Colin Bowling and Ian Sidaway